NAKED
FASHION

THE NEW SUSTAINABLE FASHION REVOLUTION

Naked Fashion
Published in 2011 by:
New Internationalist Publications Ltd
55 Rectory Road
Oxford
OX4 1BW, UK

People Tree
5 Huguenot Place
17a Heneage Street
London E1 5LN, UK

Author, Editor and Creative Director: Safia Minney
Managing Editor: Sarah Tolley
Editorial Support: Liz Wilkinson, James Minney, Liz Hitchcock, Michiko Ono, Stephanie Chaplin, Antony Waller, Ben Corley

Designed for New Internationalist by Ian Nixon.

Author acknowledgements
Many thanks to our friends at New Internationalist – Dan Raymond-Barker, Ian Nixon, Chris Brazier and Fran Harvey, to all of those who kindly contributed to this book, the People Tree team and everyone who is helping to change lives by choosing Fair Trade.

Special thanks to Andreas Pohancenik and Miki Alcalde who inspired me to write this book. Also to Phil King, Alex Nicholls, Roger Perowne, Stuart Raistrick, David Riddiford, Jane Shepherdson, Rowena Young, Kees van den Burg, Oikocredit, Shared Interest and Root Capital.

Printed in Italy by Graphicom

MIX
Paper from
responsible sources
FSC® C013123
FSC
www.fsc.org

British Library Cataloguing-in-Publication Data
A catalogue record for this book is available from the British Library.

Library of Congress Cataloguing-in-Publication Data
A catalogue record for this book is available from the Library of Congress.

ISBN 978-1-78026-041-9

Foreword

Received wisdom is often quite dim. As an example, we are told constantly that today's mainstream fashion industry is all we might desire and all we should expect. It isn't. As made clear through some of the stirring eye-witness accounts of life as a garment worker on the Global Assembly Line in these pages – such as Liz Jones' account of a visit to Dhaka – there are some startling holes in the claims of the world's biggest fashion brands that they offer unparalleled opportunity for both consumers and developing world workers.

The strength of this book is that every page turns the conventional view of the fashion landscape upside down, gives it a good shake and (charmingly) disposes of the offending idea in the nearest trash can. Instead, we are offered just about the most inspiring alternative models (of business, shopping, working – and even actual alternative models in the form of Summer Rayne Oakes) imaginable. And this is genuinely liberating.

We should hardly be surprised because People Tree, the brand created by Safia Minney, has no truck with the pervading fashion business model which involves inadvertently or purposely chewing up environmental resources and capitalizing on the world's most vulnerable and dispensable workers. And People Tree and Safia Minney bring you this book. Their approach is unashamedly producer-centric and with a long-term view of the planet and its citizens. All of which means that when you embrace this sort of fashion and creativity you do more than design, write about or buy a vest-top or pair of jeans. You support communities, protect indigenous textile weavers and designers, help to realize Millennium Development Goals such as getting girls into education and bolster ecological resilience. As the actor Emma Watson explains, Fair Trade fashion brings genuine and measurable results to some of the world's most vulnerable communities.

Not surprisingly, up-and-coming designers, writers, commentators, stylists, textile producers and graphic designers, illustrators, artists – you name it! – are all attracted. They want their professional lives to have resonance and purpose. They recognise that fashion is an important tool and they see the examples of design companies such as Terra Plana or From Somewhere who do things differently. As people working to raise the profile of fashion that matches ethics to aesthetics, we meet these potential change-makers all the time. Sometimes we're inundated with questions! Now we can gently usher them towards *Naked Fashion* as an indispensable primer.

Ladies and gentlemen, the Fashion Revolution is now under way!

Livia Firth
Lucy Siegle
London, July 2011.

NAKED FASHION
CONTENTS

Introduction

Creativity, compassion and consumption have to learn to go hand in hand. At 18 years old I worked in the advertising industry. I'd see talented creatives at the top of their class scoop up creative awards in the finest London hotels and at Cannes. Bathed in golden light, champagne flowing, surrounded by beautiful people – but then we'd be out at lunch and they'd confide about how uncomfortable it was to create advertising for products that nobody needed, that polluted the planet. They'd say, what about spending our energy-raising awareness and finding solutions to the real issues of human rights, poverty and environmental destruction? What about promoting social inclusion, more responsible consumption and more sustainable lifestyles? What if design, creativity and media could be used to change the world?

For many people at that rat race / 'what's the point of it all?' moment in their career, travel or time alone in nature has triggered a crucial switch away from our habitually amused-to-death lives. Get some fresh air. See parts of the world that function very well without our level of consumerism. See how conventional economics and consumerism are stripping land and natural resources away from farmers and fisherfolk and concentrating it all into the hands of a few business owners, investors and their army – the advertisers, creatives and marketeers who make consumption so seductive, even at the cost of our planet and our sanity.

Exactly what happened in the 1950s in the West is happening in India today, as women in the villages are seduced by fashion and beauty billboards to buy one-rupee sachets of shampoo.

This book looks at how fashion, an industry and a tool for popular culture, is changing. From rural villages in Bangladesh to 'upcycling' ateliers in London and Melbourne and boutiques in New York, Tokyo and Paris, sustainable fashion pioneers, creatives and consumers are demanding a fashion industry free of worker exploitation. They are talking about a new industry that sustains this planet, that looks at real role-models and does not exploit our insecurities through 'body fascism'.

The world is seduced by the imagery of the global fashion brands. We hope *Naked Fashion* will inspire you to be part of the change we need to be.

Safia Minney
London and Tokyo, July 2011

MIKI ALCALDE

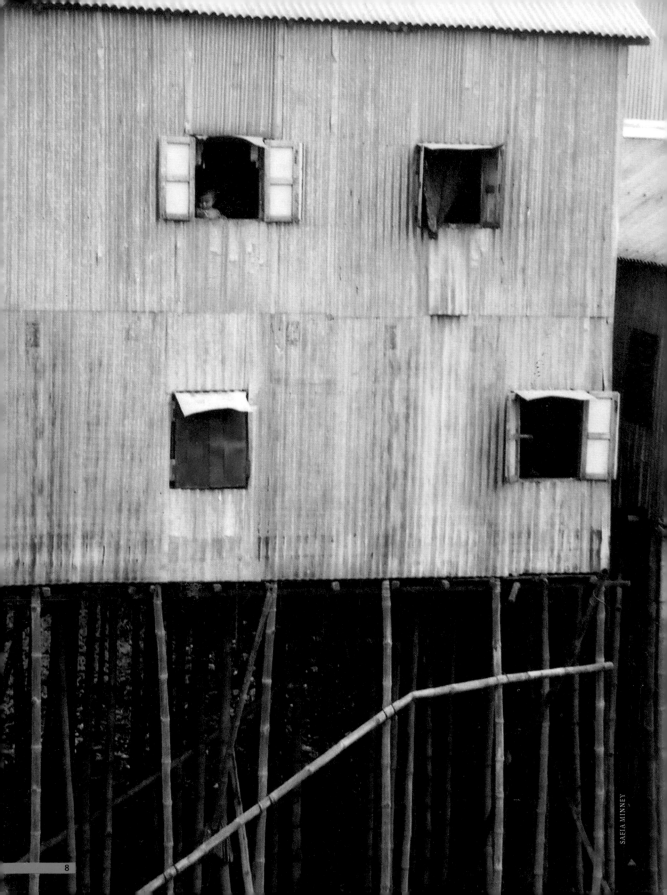

Fashion: The Un-Glam Side

*Home to garment factory workers
in Dhaka, Bangladesh.*

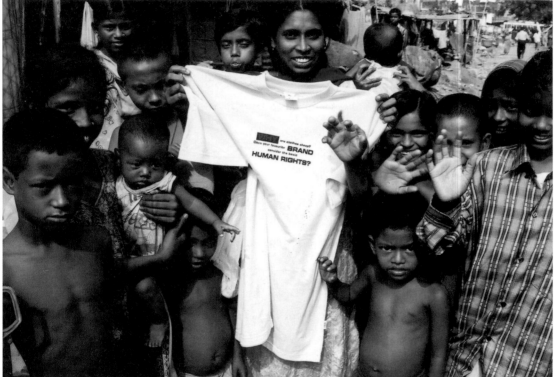

People Tree and its sister NGO Global Village have been supporting garment factory workers since 1996 – helping them fight for their rights through their trade union by financing the secretariat, marches and materials for the National Garment Workers Federation, Bangladesh.

**Why are the clothes you buy so cheap?
Does the brand you love take care
of workers' basic human rights?**

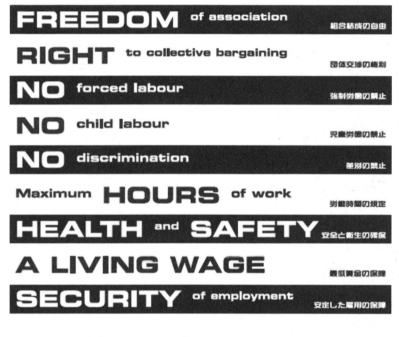

FREEDOM of association 組合結成の自由

RIGHT to collective bargaining 団体交渉の権利

NO forced labour 強制労働の禁止

NO child labour 児童労働の禁止

NO discrimination 差別の禁止

Maximum **HOURS** of work 労働時間の規定

HEALTH and **SAFETY** 安全と衛生の確保

A LIVING WAGE 最低賃金の保障

SECURITY of employment 安定した雇用の保障

GLOBAL VILLAGE **People Tree**

The real cost of fashion: people

Safia Minney's journey began in the advertising industry. But she soon saw the reality beneath the glossy image: sweatshops, slums and child labour.

The price tag on the fashion you buy rarely covers the real social and environmental costs – and here's why. For many developing countries, clothing manufacture is a leg-up into industrialization and so-called development, and is a substantial part of their earnings. In Bangladesh, clothing exports account for 70 per cent of GDP and the industry employs over three million workers, mostly women. The clothing industry offers opportunities to low-income countries because of the relatively low cost of setting up factories, and a burgeoning population that provides a constant supply of deft hands as semi-skilled labour. Developing countries end up competing with each other to be the world's garment factory, in what has been called a 'race to the bottom' for wages, health and safety and job security.

I rarely fly business class, but when I did some 10 years ago I picked up an in-flight magazine with an ad boasting, 'Rosa 50c now 30c an hour'. Rosa was a garment worker in Honduras and, back in the mid-1990s, her hourly rate had fallen. The advert was using Rosa to seduce me into bringing my clothing orders to her factory, where she and her friends were waiting to stitch my clothing and there was no labour union to get in the way. There is a similar situation in Bangladesh, where, despite inflation running at seven per cent each year, labour costs have stayed the same. The minimum wage in Bangladesh only increased in November 2010 to 3,000 taka ($40) per month, after 10 years at 1,660 taka ($21).

In search of a livelihood

2010 was a turning point, which for the first time saw more people living in cities than in the countryside. This is not just thanks to the concentration of wealth, investment and work opportunities, and not just to the world's population having grown from 4.5 billion to 6.6 billion in the last 30 years. Something more sinister and systematic is going on. The last three decades have made subsistence living and farming a struggle, with governments, advised by national and multinational businesses, shifting the terms of trade to favour large and intensive farms. Appropriation and privatization of the 'commons' (the common land and forests that were shared by communities) has also stolen away the lifeline for many families. The Modhupur Forest and other forested areas in Bangladesh have shrunk to 10 per cent of their original size in just 30 years, displacing and impoverishing hundreds of thousands of people.

With farm-produce prices hitting an all-time low, farmers struggle to cover their production costs, and are increasingly at the mercy of seed and chemical companies. Work that once earned a decent living has become full of economic insecurity, and climate change is pushing the farmer closer to the edge. Little wonder, then, that 100,000 farmers have committed suicide in India over the past decade and that the rural population is marching to the cities to find work and hope.

How rural poverty, low wages, policy and trade undermine the poor

I'm dressed in a *shalwar kameez*, posing as a fashion accessories buyer from London. My guide

A worker shows the label of a garment by a high-street brand made in sweatshop conditions. The name has been obscured for legal reasons.

takes me to Lalpatti, the red-light district of Old Delhi, to visit workshops, their owners all anxious for my orders. The tiny rooms, perhaps five or six metres square, sit behind a labyrinth of narrow red-brick helter-skelter pathways and steep stairwells. The cells are home to over 100,000 children between 8 and 16 years old, who work 14 hours a day making shiny, beaded accessories, eating and sleeping in the same room. The children here come from Bihar in the northeast, from the Punjab on the border with Pakistan, and even from Nepal. They are all polite, well-mannered and grown-up looking. Many have come through brokers that comb rural villages looking for impoverished families, promising them a good working opportunity for their sons and giving them cash to sweeten the parting from them.

Rashid is eight and from a rural hand-weaving Muslim community. His father lost his job to machine looms. With few opportunities for his father, Rashid was sent to Delhi. Like many of the 20 boys making cheap accessories for the British and US high streets, he sends home most of his monthly wage, a mere $10 after 'living and food expenses have been deducted'. But today

he is lying at the edge of the room, feverish and unable to work, while his friends work cross-legged around him, sitting up at a low bench table. It is an unpleasant reminder of how tough life is as a child labourer in Delhi. Rashid is the same age as my son and has the same name as my brother. The only difference is an accident of birth.

Child labour is caused by adult poverty. Wages for a child are between a third and a half those for adults, so once a family has been forced apart by economic hardship and the child has been exploited, that child takes another adult's job in a garment factory or accessories workshop, and the downward spiral continues.

The change is coming from the people

The Fair Trade movement, NGOs and trade unions have long been calling on governments and the international business community to deliver on the Millennium Development Goals to reduce global poverty. Governments find it difficult to hold business accountable.

Gradually, however, some governments are beginning to take the initiative in promoting accountability, transparency and better trading practice. Consumers are demanding better practice from the brands they love, and the pressure on businesses to put content behind their codes of conduct is forcing at least some of them to reorganize the way their teams buy and sell products. We all need to keep up that pressure so that children like Rashid no longer end up in this rabbit warren making accessories.

MIKI ALCALDE

A garment factory worker in the slum on her day off helping her children with their homework.

'If you pay a little more, we can live a little better'

Fashion pundit and queen of reality journalism Liz Jones travelled to Bangladesh to see the unglamorous world behind the catwalks and designer handbags. The newspaper article she produced had a huge impact. Here Liz talks about her trip to the slums of Dhaka.

I'm standing on the brink of hell. I'm on the edge of one of Bangladesh's biggest slums, Kuni Para, in the north of the capital, Dhaka, and a tide of humanity is surging past me. No-one is chatting. No-one is smiling. It's 7am, and the workers, mainly women, are off to their shifts in the garment factories that litter this city. In front of me are three pieces of bamboo, propped above a sea of raw sewage and garbage, reaching into the warren of corrugated iron.

It's already nearly 40 degrees, and the stench is overpowering. It's drizzling, and the bamboo is slippery: one false move and I will tumble into the fetid soup. I'm glad I'm wearing my bargain flip flops bought for a few pounds in London; I figure I can throw them away when I get back to the hotel. I'm wearing a *shalwar kameez*, in the hope I will blend in. I grasp a passing woman's hand, and enter the darkness.

I grope my way along the narrow corridors. The tin walls are running with water, and there is a tangle of electrical cables above me; only last month, a fire killed over 100 people not far from here. I pass what my guide laughably calls 'the bathroom'. It is a cold water pump; 100 people share it. I tell my guide I want to find a child labourer. 'That's easy,' he says, and leads me up a ladder, along a narrow plank that creaks under my weight, and into a stinking hole. This is where I find Dolly.

Dolly is 14. She sits cross-legged on a wooden platform (it's too hard to be called a bed) resting on bricks; it collapses when I join her, and even though she must be desperate for sleep – she has just come off a 12-hour shift – she giggles, covering her mouth, and smooths the plastic sheet for me.

I ask what her job is. 'I'm an embroiderer,' she says proudly. The very young are prized for their keen eyesight and tiny fingers. Does she ever have a day off, time to spend with friends? She looks at me as though I'm insane. 'I work seven days a week. I do not have a day off.' She won't tell me the name of the factory she works in, for fear of getting sacked, but she does tell me what she earns: 2,800 taka a month, including overtime. The minimum wage in 2010 in Bangladesh was 1,662 taka a month, about 80 US cents a day.

What ambitions does she have? 'I want to one day work on a sewing machine.' Is she happy? Her big eyes swivel, confused. She clearly has no concept of happiness. I hug her, and she feels as fragile as a sparrow. 'My mother has been worried, because I have been losing weight,' she says. 'I eat rice, but I give the shrimp to the babies, when my mummy isn't looking.' I meet Hashi, Dolly's mum. She is 35, and has been told she is too old to work in the garment industry. The age of 16 is ideal: a young girl is biddable, and not yet short-sighted from all the close work in crowded, poorly lit conditions. Isn't it interesting that the ideal age for

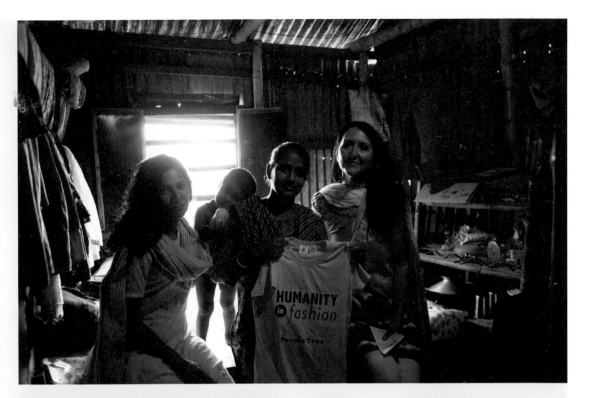

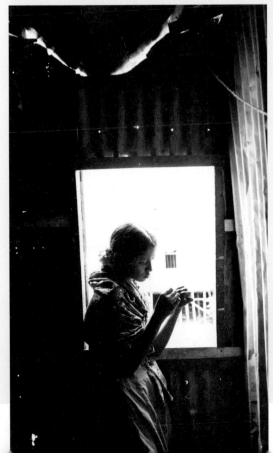

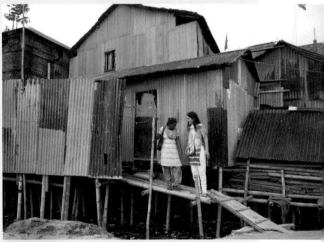

Top: Liz Jones meets garment workers with Safia Minney.
Above: Liz is shown around the slum.
Left: A young garment worker reflects in her home.

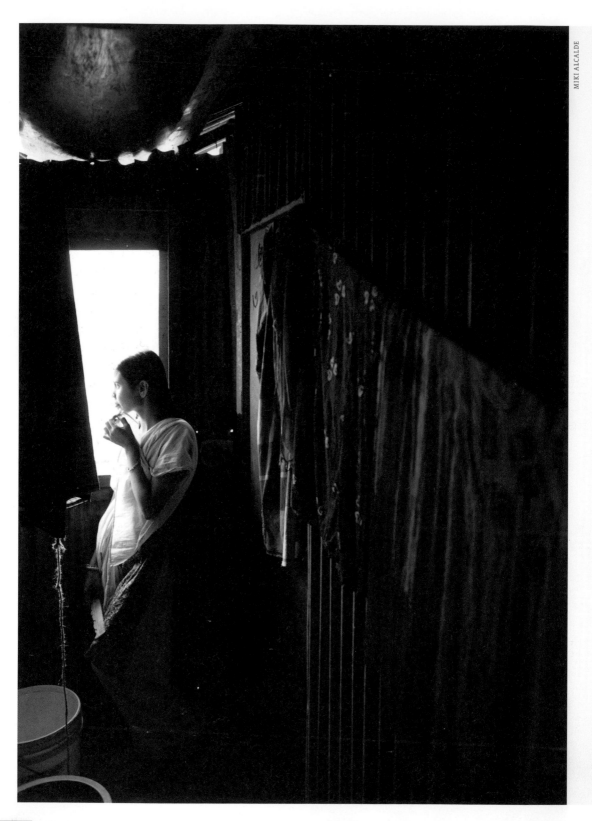

women on the catwalk, and the women who walk this obscene, narrow runway of bamboo, is about the same? The women at the top of the fashion tree are thin through choice; the women here simply cannot afford to eat: the price of rice, too, has shot up, from 20 to 35 taka a kilo.

I spend most of my professional life talking to the people who run fashion brands. The CEOs reassure me, endlessly, that they take care of the people who make clothes for them. I am always asking the same, unanswerable question: isn't someone, somewhere, getting screwed? And I am always told the same thing: We order in bulk, it's economy of scale, we are incredibly efficient. I am always being directed to the 'ethical' box on their whizzy websites, full of pictures of smiling, dark-skinned women in sun-filled factories. These brands can't be lying, can they? And so I have travelled to Dhaka in search of the people I suspected all along were being screwed. And they are shockingly easy to find.

Hashi's neighbour is Jasmine, who is 26. She is on what could loosely be called maternity leave from her job as a machinist. She worked until the day she gave birth, and is now on unpaid leave. She is about to send her middle child to join the oldest at their grandparents' village. How often will she see her? 'Two, three times a year.' Does she ever feel despair? 'I am used to it. There is no point feeling despair.' What is her most prized possession? 'I don't really have anything.'

There are three million garment workers in Bangladesh, and 85 per cent of these are women. I get in a cab to the tiny office of the National Garment Workers Federation to meet some of the workers who have been unable to stomach the terrible conditions any longer. First, I meet Sharti

Akta. She is 25, and worked at a factory called Acropoly. It was a new factory – it had been open for only five months – but as soon as the workers went on strike in June, it closed down. I ask her to tell me which British fashion brand she was working for, and she holds up the label she smuggled out of the factory past the guards or 'muscle men' who wield giant sticks and baseball bats, and who search every worker as she leaves.

And, finally, I meet Khodeza Begum, a 40-year-old grandmother who looks two decades older. She tells me she worked at a factory called New Age for 16 years. Then, three months ago, she couldn't go to work for 15 days because she had suffered a severe burn to her leg: her job is to iron clothes. She took home 2,700 taka a month, and lives in a room with five other people. When she returned to work, she was told she had been sacked. 'Normally, I would crawl to work,' she says, 'but I could not crawl with the pain. After 16 years of working 12 hours a day, I have nothing. I'm like an old dairy cow. You might as well slit my throat.'

I am not calling for a boycott of Bangladeshi clothing, which would be a death sentence for millions. I want every fashion brand sold in the UK to insist on a minimum wage of 5,000 taka a month. The reality of a 5,000 taka minimum wage? It would mean the price of a pair of jeans costing £20 ($32) on the British high street would increase by 80 pence ($1.30). Eighty pence. I ask Sharti if she has a message for shoppers in the West. 'Come and see where I live. If you pay a little more, we can live a little better.'

Liz Jones is Fashion Editor at Large of the *Daily Mail*. This article originally appeared in the *Daily Mail* in July 2010.

> **The women at the top of the fashion tree are thin through choice; the women here simply cannot afford to eat**

Fashion's impact on the Earth

Safia Minney looks at the environmental damage done by fashion – and sketches a new way forward.

It seems like a very small thing to us, choosing a t-shirt or a dress made of organic rather than conventional cotton. But it can make a big difference at the other end of the chain.

The environmental impact of fashion is something that needs to concern us all. What's clear is that fashion's environmental footprint at the moment is unsustainable. The evidence is overwhelming. For example, the British clothing and textiles sector alone currently produces around 3.1 million tonnes of CO_2, two million tonnes of waste and 70 million tonnes of waste water per year – with 1.5 million tonnes yearly of unwanted clothing and textiles ultimately ending up in landfill. This means that we each throw away an average of 30 kilos a year.

We need to consume less fashion and wear our clothes for longer, while the fabrics and clothes that we do buy need to have more 'value added' – benefiting not only the farmers but also as many artisans as possible in its transformation to clothing.

Fair Trade can make a big difference here.

Fair Trade takes a long-term view, working in partnership with producers and enabling communities to 'invest' in environmental initiatives and diversify. It recognizes that, if farmers are given even half a chance, they will protect the environment. After all, why would people whose lives are so dependent on the resources of their natural surroundings, destroy their environment? The answer is that they only do so when driven to it by low prices, unfair terms of trade and the insecurity that comes from not knowing where your children's next meal will come from. They only do it when there seems to be no alternative.

Fair Trade, social businesses and new economics are leading the way in showing how we can protect the environment and help the poor feed themselves.

Supporting low chemical inputs, transitional and organic farming is also vital. Polyester, the most widely used manufactured fibre, is made from petroleum. The manufacture of this and other synthetic fabrics is an energy-intensive process requiring large amounts of crude oil and releasing millions of tonnes of CO_2. With oil supplies dwindling, we have to find alternatives to oil-intensive farming methods now, before it's too late. Organic farming takes 1.5 tonnes of CO_2 per acre per year out of the atmosphere.

Water is another vital resource being over-consumed by the fashion industry. And, as water scarcity becomes as big an issue as global warming, this is critical. Conventionally grown cotton is one of the most water-dependent crops to be grown. It takes over 2,000 litres of water to produce the average t-shirt with conventional cotton. Organic and Fair Trade cotton has helped to reduce water consumption by over 60 per cent in the Indian state of Gujarat, by supporting farmers who invest in drip irrigation.

The conventional cotton industry has a devastating effect on farmers and the environment. Heavy pesticide use reduces biodiversity, disrupts ecosystems and contaminates water supplies. Worse still, pests exposed to synthetic pesticides build up a resistance to them so that, each year, farmers

Fair Trade and ecology

Each new fashion trend leaves a new chemical legacy

have to buy and use more pesticides to grow the same amount of cotton. Not only does this increase the annual damage to the environment, it means the farmer gets less and less profit from the crop.

These pesticides also harm the farmers and their families. Many of the chemicals used in cotton farming are acutely toxic. Around 10 per cent of all chemical pesticides and 22 per cent of all insecticides used worldwide are sprayed on cotton crops. Cotton growers typically use many of the most hazardous pesticides on the market, many of which are organophosphates originally developed as toxic nerve agents during World War Two. At least three pesticides used on cotton are in the 'dirty dozen' – so dangerous that 120 countries agreed at a UNEP conference in 2001 to ban them, though so far this hasn't happened.

The World Health Organization estimates that three million people are poisoned by pesticides every year, most of them in developing countries. When pesticides leak into the environment, chronic poisoning can affect entire communities. Symptoms of chronic poisoning include numbness or weakness of arms, legs, feet or hands, lethargy, anxiety and loss of memory and concentration. Young women are particularly vulnerable – exposure to pesticides can affect the reproductive system, causing infertility and spontaneous abortions.

In the light of all this, any support we can give to small farmers growing organic cotton is vital. Organic cotton is grown as a rotational crop alongside organic foods that are often consumed by a farmer's family, with the surplus sold locally. But cotton farmers in India trying to make the transition to organic often struggle to do so because the soil takes five years to recover its yields as it is weaned off agrochemical methods. They desperately need more support from the government. The only support at present is coming from NGOs and advocacy organizations – and from consumers prepared to pay a Fair Trade premium and to insist on organic cotton.

If we pay farmers a higher price for their cotton, they will be able to diversify their crops, use less polluting farming methods and protect the environment. Though it must be said that an even greater service to small farmers – and 99 per cent of cotton growers live in the Global South – would be if world prices were not kept artificially low by the glut of cotton on the market caused by the US government's extraordinary subsidies to its own farmers. In 2002, for example, US cotton was being dumped on the world market at 61 per cent below the cost of production.

As this suggests, there are huge forces at play here. The same global trading system that keeps so many of the world's people poor also destroys the environment. The economic and accounting system we have today only measures financial outcomes, not the social and environmental bottom lines. Our present system pursues short-term profit, propelling environmental destruction and widening the gap between rich and poor.

Faced with these huge issues, it is easy to throw up our hands in despair and feel powerless. But at least in the area of supporting Fair Trade fashion, organic fabrics, second hand and upcycled clothes, we have something clear and positive we can do.

Fair Trade and organic fabrics currently account for a tiny percentage of the total amount of cotton sold worldwide. We have a lot to change! But every time you opt to support Fair Trade, organic or second hand clothing you are making a difference.

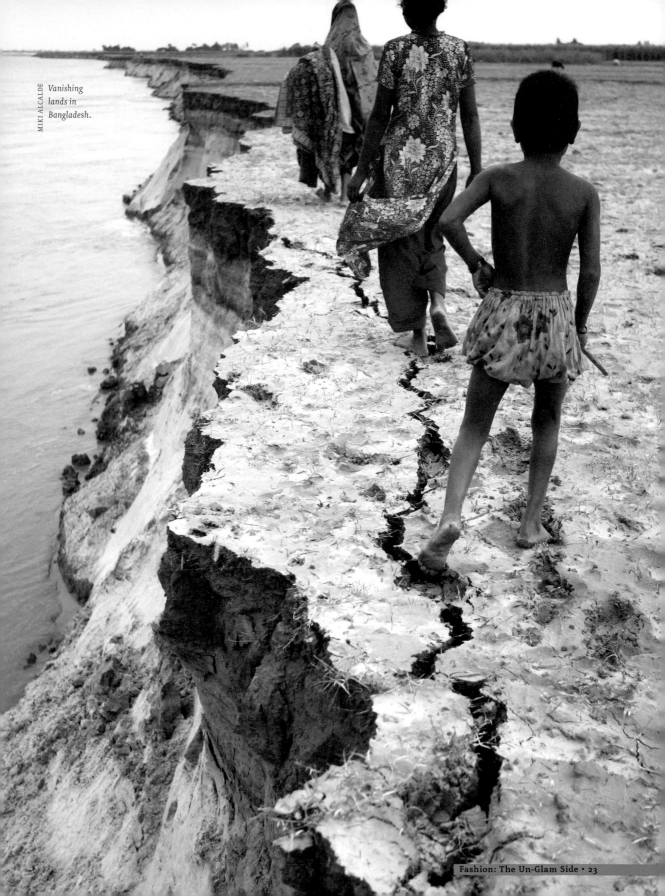

MIKI ALCALDE *Vanishing lands in Bangladesh.*

Fair Trade: Part of the Solution

A shuttle holding unbleached thread sits on newly hand-woven fabric in Bangladesh.

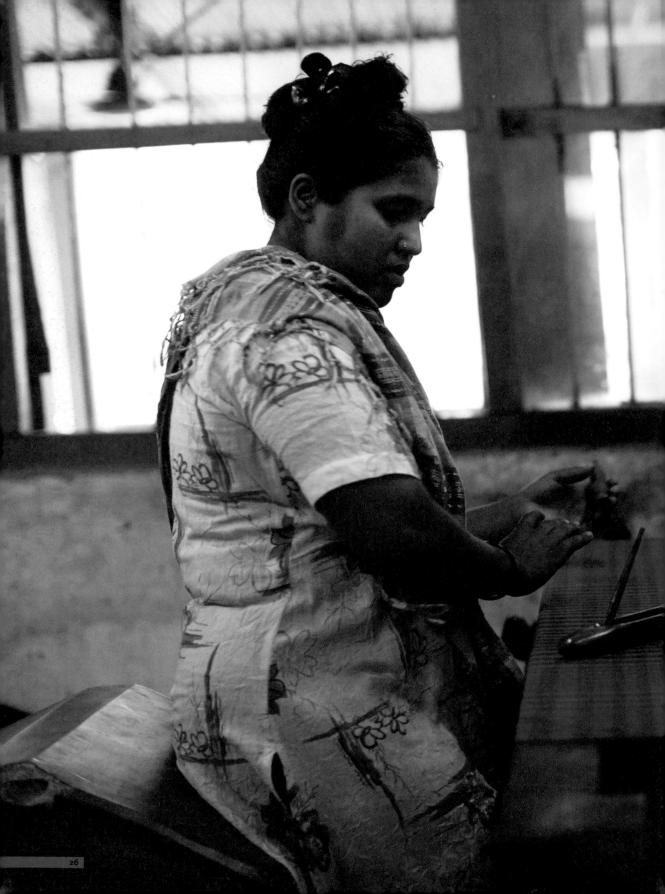

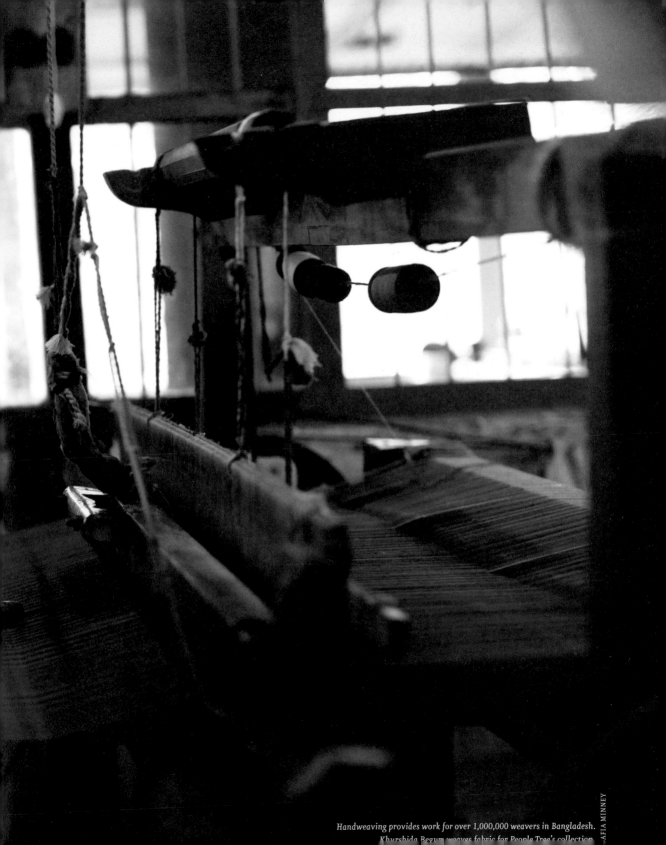

Handweaving provides work for over 1,000,000 weavers in Bangladesh.
Khurshida Begum weaves fabric for People Tree's collection.

Leaving commercialism behind, illustrator **Chris Haughton** *remembers how a journey to India changed his attitude to design – and to life.*

I have always been very passionate about design. Since I was around 10 years old, I knew for certain I wanted to be a designer. I never would have guessed, but the thing that had the most effect on my design career was the decision to go backpacking in India while I was in art college.

When I came back to Dublin after travelling, I remember going to the graduate shows by my fellow students and being struck by how unnecessary most of the designs suddenly seemed. The year before, I hadn't seen them as unnecessary at all.

It occurred to me that having been away in the developing world had really altered my views. It seemed to me that, in the developed world, designers are designing increasingly unnecessary products and advertising for consumers who are awash in superficial consumerism. Outside of this commercialism, there is a very real need in the real world for better designs and thorough design solutions. I began to resent the commercialism of design. I started reading *Adbusters* and Naomi Klein's *No Logo* and, although I was really passionate about design, I was torn and keen to work somehow outside of the commercialism of design.

After I left college, I began working as a designer for a music promoter and large music venue in Dublin. I was doing press, billboard posters and flyers for some very large and exciting music festivals and events. Music was one of the areas of graphics I was interested in working in, as it tends to be quite creative and non-commercial, but after only eight months of working I was as disillusioned with it as I was with the rest of the design world. I left to try to set up my own work as a freelance illustrator and moved to London.

I hadn't actually heard of Fair Trade in clothing before I met People Tree, around eight years ago.

Chris Haughton is an Irish Illustrator living in London. He was listed in *Time* magazine's DESIGN 100 for his work for People Tree. His debut book *A Bit Lost* has won seven awards in four countries including 'Best Picturebook of the Year' (Holland) and 'Bisto Children's Book of the Year' (Ireland) He has just started digitalhandmade.com which is a collective of artists who make limited edition Fair Trade rugs.

When I heard of the work that was being done, I thought: 'Wow! This is exactly the area I want to be involved in. This is an area where good design is needed.'

As an illustrator, I was always meeting and working with advertising agencies and marketing people who, understandably, were cynical about the multinational brands they are promoting. When you are working in art college, you have a very pure idea of what design can be. But when you get working for real companies, the day-to-day realities and commercial pressures come to the fore and design becomes a very mundane occupation. I think everyone who works in design gets that feeling. When I met Safia and the People Tree team, we had a chat and she was so passionate about the work she was doing. That in itself was such a huge breath of fresh air. A lot of the people working in People Tree have taken big cuts in their salaries to come and work for something they believe in and, as Safia has said, if we can do well as a company we can really change the whole industry. I just thought the whole idea was so inspiring and exciting, I remember cycling home from the meeting and being suddenly excited by the potential of design again.

I am fully supportive of Fair Trade. I think it's perhaps the best answer to development that we have. I have lived in Nepal and India for over a year and seen the work being done not only by Fair

Chris has designed interiors for hotels and People Tree stores.

Trade but NGOs. I think Fair Trade works because it's more of a bottom-up approach. It has its faults, but I think it's the best solution we have.

The producers that Fair Trade works with are some of the most marginalized or disenfranchised peoples in the world. They often have no access to education or other means to improve their situation. Engaging them and helping out is not only fair and just, but helps alleviate some of the extreme disparity between rich and poor that globalization and industrialization have brought about. The long-term cost of not addressing that disparity now may well prove to be more costly over time as that disparity grows. Most political conflicts and unstable political regimes exist because there are many people who are disenfranchised and literally have nothing to lose – almost every war has a

Without any information on the products and the ways they are produced, the natural tendency is to buy the cheapest available

background of a disenfranchised population that is usually, quite justifiably, angry.

Consumers need to be aware also. We are very removed from the process of production these days. Without any information on the products and the ways they are produced, the natural tendency is to buy the cheapest available. Supermarkets and outlets have no choice but to source cheaper and cheaper products. How they are made so cheaply is of no concern to the importer because it is of no concern to the consumer. The Fair Trade mark and other consumer standards are the only real ways to counter that.

For anyone who is starting off as a designer, I would really encourage getting involved with local activist groups and voluntary work. You really can meet some very interesting people – and do really great, worthwhile design. There are plenty of great NGOs and groups to join and help out with. It's a great way to start out with work, even if it's often voluntary. If I go along to any activist meetings, I have to be careful what I say – I try to keep it quiet that I am a designer, otherwise I'll be up to my ears designing, and that work always leads to paid work. I have a friend who volunteered to do leaflets and odd-job work for Greenpeace and a year later he got paid to go to Glastonbury to 'design' their tent!

My last thought is that I can't recommend going travelling enough – it's the best thing I've ever done.

Chris's artwork for People Tree's youth collection

Fair Trade and organic cotton baby suits.

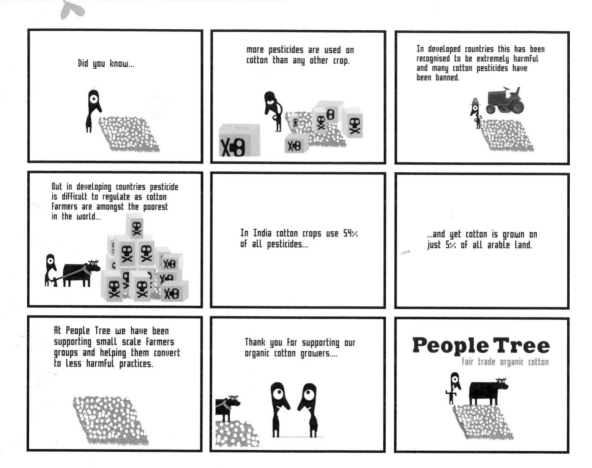

Check out Chris's video about organic cotton at http://chrishaughton.com/people-tree-book

Facing page shows designs for People Tree, handmade paper, note books, T-shirts and felt crafts.

LINKS

My talk at OFFSET about my work and what started me in Fair Trade may be useful to young designers
www.vimeo.com/11102357

Really good talks on sustainability and theory from the Long Now Foundation
www.longnow.org/projects/seminars/

The BBC talks with Jeffery Sachs, a Nobel Peace Prize-winning economist, about poverty www.bbc.co.uk/radio4/reith2007/

New Economics Foundation – their intro is here: http://nin.tl/jFFr23
You can download some of the stuff at http://nin.tl/jTfNu7 The 3 planet visualization is very good.

I'm involved with these a little www.ark-inc.info

This is a community of people who send each other news about sustainable design stuff www.o2.org/index.php

And this is a very good activist group www.wdm.org.uk

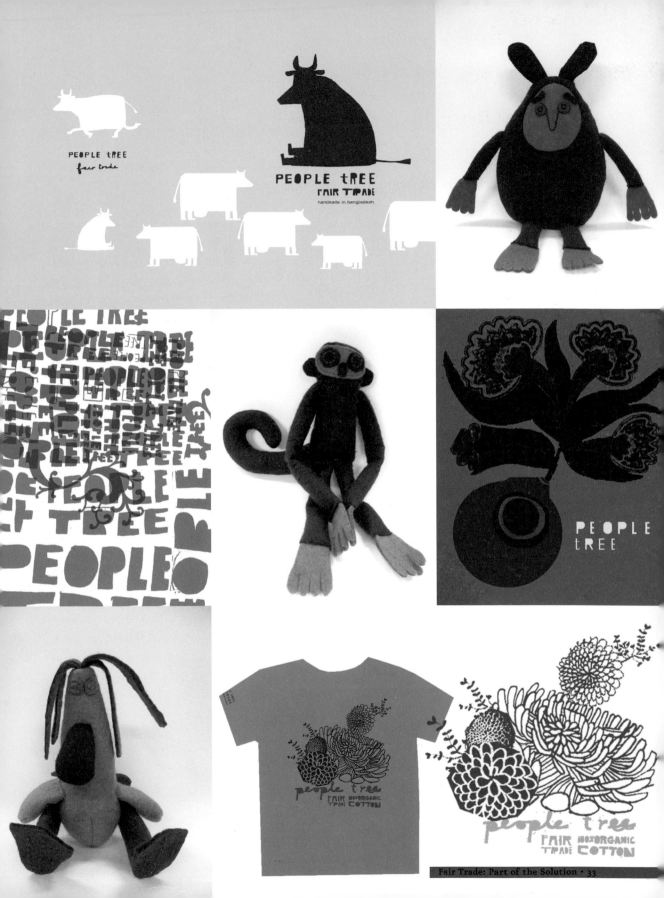

World Fair Trade Day

Safia Minney recalls the launch of an international day to celebrate the Fair Trade movement.

World Fair Trade Day was launched by People Tree and Global Village, its sister NGO, and endorsed by the Fair Trade movement, in 2001. World Fair Trade Day is now celebrated throughout the world on the second Saturday of May, with rallies, cultural and media events, craft competitions, seminars, Fair Trade breakfasts and fashion shows.

The Fair Trade movement was started in the 1960s by passionate people wanting to see an end to poverty and to strengthen People's Movements in the developing world. By 2001 and the launch of World Fair Trade Day, Fair Trade was becoming a global phenomenon, growing rapidly in Europe, with Fair Trade foods having won their place on supermarket shelves and 3,000 Fair Trade shops. Fair Trade coffee was moving into coffee shops throughout the US, and Japan boasted a network of 350 Fair Trade shops.

The Fair Trade movement is the biggest proof of the Butterfly Effect, where individual good deeds and actions change the face of society, the relationship we have with each other, and the way we do business. From the unlikely tweed-flat-capped hero who promised his local supermarket in the UK that he and his friends would buy six boxes of Cafédirect a week if the supermarket stocked it (they still do), to the Fair Trade shop owners in Kumamoto, southern Japan, who after 15 years of campaigning and working with the Fair Trade movement set up a system and launched the first Fair Trade town in Japan in May 2011.

This is conscious consumption and grassroots activism at its best. People getting on with their lives, self-appointed volunteers who have brought Fair Trade products to the forefront of retail by putting their money where their mouth is and writing to companies to tell them to improve their business practice. Consumers working closely with Fair Trade Organizations that are as much campaigning groups as they are social business ventures – working with farmers and artisans in the villages and forests to bring a form of 'trade' that respects their culture, society and environment.

Fair Trade is one way to empower economically marginalized people; the other is to give them a voice. That is why, alongside training workshops for organic cotton farming and technical skills builing for artisanal groups, you will find people challenging government and big business to overcome the policies, terms of trade and systems that prevent people from earning a fair price and improving their lives.

Being alive is being political. As Martin Luther King Jr said: 'Before you finish eating breakfast in the morning, you've depended on more than half of the world.' People around the globe are campaigning for a fairer trading system that makes people and the planet central to everything. It will not be long before we realize that our old economic system – with financial profit its single measure of success – is unable to sustain itself. After all, exploitation that ignores basic human rights or unsustainable use of our planet's limited natural resources is adding a million more people to the ranks of the hungry each year. Fair Trade is proving a new economic and business model that embraces equally people, planet and profit.

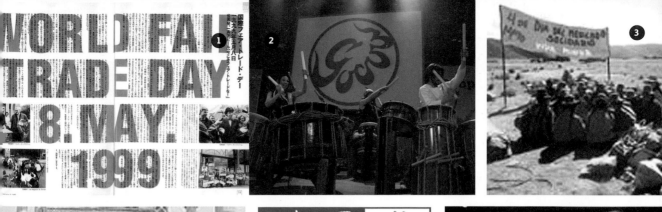

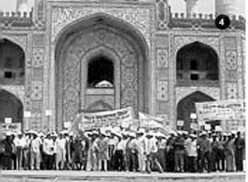

Kids Need Fair Trade
World Fair Trade Day
May 12 2007

FAIR TRADE ORGANIZATION
IFAT • THE INTERNATIONAL FAIR TRADE ASSOCIATION

WORLD FAIR TRADE DAY
FAIR TRADE + ECOLOGY
Be the Change!
9 May 2009

Say 'NO' to Sweatshops

People Tree

FAIR TRADE AND FORESTS
WORLD FAIR TRADE DAY
14 MAY, 2011

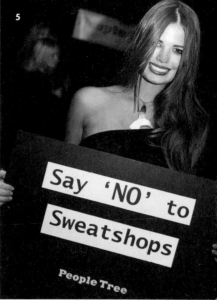

People Tree GLOBAL

Fair Trade - Made in Diversity
8 May 2010
World Fair Trade Day

1,2 *Press and drumming to celebrate World Fair Trade Day in Japan;* **3** *MINKA indigenous artisans celebrate in Peru;* **4** *Five hundred artisans celebrate in front of the Taj Mahal;* **5** *People Tree fashion show, London;* **6,7** *KTS in Nepal celebrate World Fair Trade day;* **8,9** *Japan Media Conference & fashion shows.*

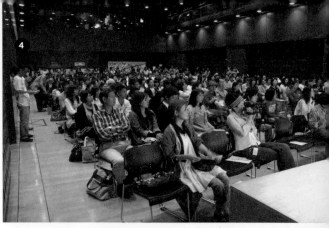

1 London – Agrocel India Project Manager, Hasmuk Patel; 2 Preparing a show, Hong Kong; 3 Workshops in Japan; 4 700 people gather in Tokyo for World Fair Trade Day; 5 Tokyo 'School of Fair Trade' club; 6 Seminar in Asia; 7 G8 Fair Trade show and seminar, Hong Kong; 8 Fashion show, London; 9 World Fair Trade Day, Hong Kong; 10 Fair Trade campaigner, Austria; 11 Fashion show at Prince Charles's home, Clarence House, in London; 12 Japan – World Fair Trade market place; 13 London Fair Trade 100 Campaign; 14 Producers celebrating World Fair Trade Day, India; 15 'School of Fair Trade' university students in Japan show their support for World Fair Trade Day; 16 Celebrating World Fair Trade Day; 17 Fashion show, London.

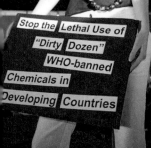

Stop the **Lethal** Use of "Dirty Dozen" WHO-banned Chemicals in Developing Countries

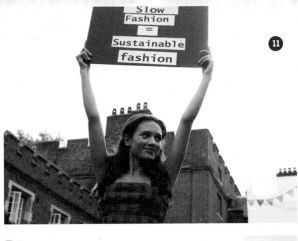

Slow Fashion = Sustainable fashion

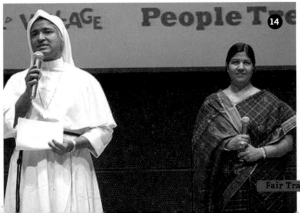

VILLAGE People Tree

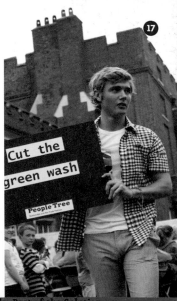

Cut the green wash

People Tree

The Fair Trade Movement: Japan

Yoshiko Ikoma
Journalist and fashion commentator

When I was editor of *Marie Claire Japan*, we did a feature on ethical and Fair Trade fashion – it was a first for Japan. Back then, in 2008, department stores and select shops were just beginning to take an interest and buy in Fair Trade and ethical fashion brands.

Now the earthquake has brought about a paradigm shift and people are changing their lifestyles to low energy and being more eco in their shopping. People realize that a lifestyle based on high energy use, as it has been up to now, is completely unsustainable. The government and businesses are promoting 'Cool Japan' – a campaign to reduce electricity use, turn off air conditioners in offices and homes and dress for a warmer climate to save electricity. Future trends include the appreciation of craftsmanship and hand skills; this is a reaction against fast fashion, mass production and mass consumption. It is a search for something really meaningful that contributes to society and is made with respect for the environment.

Io Takemura
Stylist and eco-fashion journalist

I studied fashion design at high school in Japan and then went to the UK to do a BA in fashion promotion and illustration. My friend was working at Junky Styling so I joined them and worked as a junior designer and stylist. In Japan I gained technical skills in sewing at high school which were useful at Junky Styling. I didn't know much about eco-fashion at the beginning, but I started going to talks, getting involved in the production, then the branding and talking to customers. I learned about the issues around sourcing in developing countries, too. I love everyone's passion in ethical fashion. The people are lovely. People don't lie, they are unpretentious and honest.

I did an MA and made short films to promote eco-fashion. I'm also a contributor to *Sublime* magazine, which is a magazine about ethical fashion [www.sublimemagazine.com]. I really wanted to spread the eco-fashion movement in Japan. Fair Trade fashion is really good to build awareness of traditional fabrics and livelihoods.

www.iotakemura.com

Rika Sueyoshi

Japanese TV reporter and presenter

Fashion is about being yourself – about how you feel about yourself and the world. Your choice of clothes reflects your values. I want to live in a way that respects other people and the planet. That's why I choose Fair Trade fashion and People Tree. Ten years ago I didn't give a thought to where the clothes I buy came from or who made them, but today I try to buy only Fair Trade, organic and vintage.

As a TV reporter working in the Japanese media, it's difficult to cover the issues I feel passionately about because it's all about viewer numbers. So I'm trying to create new ways of getting the Fair Trade message out, using magazines, symposiums, events and blogs.

People trust the media, but we need the media to cover Fair Trade more, and motivate even larger numbers of people to support Fair Trade. Fair Trade covers so many global issues – humanitarian, environmental, energy use – it connects everything and it creates a butterfly effect for CHANGE!

Miyako Maekita

CEO / Creative Director, Sustena, Japan's leading environmental consultancy and thinktank

Fast, disposable fashion is not cheap in the long run. And if we wear handcrafted Fair Trade and other 'slow' fashion again and again they are very good value for money.

When my mother passed away she left closets full of old kimonos, inherited from as far back as five generations. Before she died, she told me everything about each kimono: 'This one was brought by the sister of my great-grandmother when she got married and joined our family...'

In fashion, there are so many aspects to the industry that can be used to support global and eco issues. I think Fair Trade fashion is a powerful tool to promote environmental protection and the dignity of farmers and artisans. Fashion is fun. Fair Trade fashion offers a uniquely handmade product. If we can bring social values to fashion, get lots of people excited and deliver positive messages, we will get more people involved in the solution.

Michiko Ono
Publicist

I started my career in PR totally by chance. One day I was going to celebrate a friend's birthday who was in the PR industry. She couldn't leave her office as she was dealing with some crisis, so I went to help and got to know people from the agency, who later offered me a job. But after a year I got bored as I had no interest in promoting things I did not believe in. So I decided to leave the job and volunteer as an interpreter on a round-the-world cruise organized by the NGO Peace Boat.

Again by chance, after I started working at People Tree Japan, I was offered a job in PR. It is totally different from working for an agency – I can think of how to promote Fair Trade, and this is what I believe in! In my four years as co-ordinator for Peace Boat, I visited over 50 countries and saw a great deal of poverty. But I also visited Fair Trade projects and saw how work there brings pride and dignity to people, as well as money to feed the family.

The ethical and Fair Trade customer in Japan is cool, cutting-edge, style-mix and knows where beauty really comes from.

Taku Ogata
Sales Executive

I used to sell cars before joining People Tree. But with the birth of my first son I started thinking about changing jobs. I wanted to have a job I could proudly tell my kids about when they grew up.

My wife was running an online shop and People Tree was among her business partners. She told me about their activities. Fair Trade seemed a very attractive and innovative business model where sellers, buyers and producers, and their families can share pride and values.

I always hope to live simply. My family agrees that it is best to get only what we need and live accordingly. Abundance in things and information seems to be making people selfish. I would like my kids to develop a taste to choose what is really valuable and not to consume unnecessary things.

As I tried to simplify my life, I realized I did not need to eat as much. I became a bit thinner and what I wear is proportionate to my body so I wear tops from the women's collection. I don't know what my wife and kids think about it – I decided not to ask!

Meri Oda
Customer

People around me [in Japan] are changing. As I have many friends who have children, we talk a lot about how we can choose the best environment for our kids. Especially after the Earthquake, many families have moved to the countryside to live a slow life and in harmony with nature, prioritizing their health over a higher salary. As for myself, I am aiming to be semi-self-sufficient and be with my family all the time.

I think that People Tree is far more stylish than a few years ago! I've seen other brands selling organic materials like hemp and, although I know they are good, they don't look glamorous and I don't feel like buying them.

Maybe we can spread the Fair Trade idea by word of mouth? I think the market for eco-minded mothers is huge.

I'm doing my best to explain to my child about Fair Trade every time we see Fair Trade products. Now, wherever we go shopping, he says: 'Is this Fair Trade? Then we can buy it.' So I feel happy that the message is getting through.

Masaki Kagawa and Manabu 'Gaku' Kato
From Patagonia, the pioneering outdoor eco brand

Masaki: I joined Patagonia three years ago, and before that I was an acupuncturist. Through my work I started worrying about pesticides in the environment and the effect they have on our health. I have been into outdoor sports and travelling, and I was inspired by the way of life of the organic farmers whom I met while travelling in South America.

Producing things recklessly using natural resources and animal life will destroy our ecosystem and planet. We should realize this and take immediate action to protect our natural world.

Manabu: I joined Patagonia while I was studying sociology at university. I read *Let My People Go Surfing* by Patagonia CEO and founder, Yvon Chouinard, and was amazed. Since starting at Patagonia, I've become more aware of my personal environmental footprint – and I understand the importance of social businesses like Patagonia.

BUSINESSCHIC.COM.AU

Vogue and beyond

Australian fashion writer and creator Leeyong Soo on her adventures in design.

For those of you graduating from uni and considering careers now, 'sustainability', 'social responsibility' and 'Fair Trade' are familiar terms, but when I started work at Japanese *Vogue* magazine in 1999, they could just about have been vocab from a foreign-language exam.

My entry into the fashion world was largely due to hard work and good timing. I worked in Tokyo on an English-language magazine for nearly a year before finding out that a colleague had connections with someone at Japanese *Vogue*, which had just launched. I would have been thrilled do anything if it meant working at *Vogue*, so begged for an introduction, got an interview, and by September 1999, found myself assisting the English fashion director and her team in Tokyo.

Work at the magazine was fun a lot of the time, but definitely not glamorous – it takes months to put some features together and many late nights (read: early mornings). However, I managed to find time to buy a second-hand sewing machine and continue making clothes for myself, a hobby I had started at around 14. Then, on a visit to a flea market, I purchased some beautiful old kimonos and obi. I couldn't get enough of the gorgeous patterns, textures and colour of traditional Japanese dress, but it's not practical to wear in today's world. Instead, I started cutting up kimonos and obi to make dresses, and in 2002 went part-time at *Vogue* to launch my first label, Must Like Cats.

I made every garment myself, combining new materials and second-hand clothes with vintage kimono and obi fabric. I had some trouble keeping up with production, and considered manufacturing overseas. Hearing how much I'd have to pay put me off, though. Not because it was too expensive – it was the opposite. I couldn't understand how the workers could make a living at the prices I was quoted, and continued my operation solo until I was offered a different, full-time role at *Vogue*, as international fashion co-ordinator in 2004.

In my new position, I proposed and worked on various stories, all the while dreaming of launching a fashion label that was manufactured ethically. I had somehow heard about People Tree and in 2006 decided to do a collaboration project with them through *Vogue*. My proposal for the project was for leading designers to contribute patterns for garments which would be manufactured by People Tree producers under Fair Trade conditions. The garments would be sold in limited quantities in Japan and the UK,

Fair@Square: moralfairground.com.au
Peppermint: peppermintmag.com
Style Wilderness: stylewilderness.blogspot.com
Australian Sustainable Fashion Network:
melbournesustainablefashionnetwork@groups.facebook.com

and a *Vogue* story would illustrate the process and end results.

Of course, things were not as simple as they sound. It was difficult to get designers to understand what we wanted to do and explain how Fair Trade worked, and even more of a challenge to get them to participate. Finally we got our four designers – Richard Nicoll and Bora Aksu, both of whom are London based; Japanese brand Foundation Addict and Thakoon from New York – and for a while, my work was done, as the amazing People Tree team in Japan oversaw the actual manufacturing process. Several garment incarnations and quality control meetings later, we had our finished range, which we shot on top models Lily Cole, Helena Christensen, Anne Watanabe and Shalom Harlow, all of whom were generous enough to contribute their time at no cost. Add a few pages explaining Fair Trade, and the story was ready for the *Vogue* June 2007 issue, which was around the time that the garments themselves went on sale at Isetan department store in Tokyo and People Tree stores online and in Tokyo and the UK.

Of all the projects I worked on at *Vogue*, this was the one of which I was most proud. *Vogue* readers – fashionistas who may not have even heard of Fair Trade beforehand – could see for themselves that ethical, organic fashion did not have to mean 'horrible hippie hessian', and overseas media picked up on the story, as it was the first collaboration of its kind. But perhaps the most exciting result was that three of the designers signed up to continue the collaborations and this encouraged other designers such as Tsumori Chisato, Laura Ashley and Sam Ubhi to follow suit.

Now based in Melbourne again, I contribute as a writer to *Peppermint* magazine, an Australian publication showcasing eco-fashion and all sorts of related issues; write a blog on my fashion recycling and designing adventures (stylewilderness.blogspot.com); work on my label, Fourth Daughter, and have continued to work with Fair Trade groups too.

I'm just beginning to organize my third Fair Fashion show, having successfully co-ordinated a parade during Fair Trade Fortnight in 2008 and the Fair@Square festival fashion show in 2010. Both shows featured a fabulous mix of Fair Trade, eco-friendly, recycled and sustainable fashion and attracted quite a crowd and a lot of positive feedback.

Fashion is often spoken of as superficial and frivolous, but its glamour factor makes it a powerful visual tool to deliver the message of an ethical, sustainable lifestyle. Together with other members of the Australian Sustainable Fashion Network, I'm working on ways to make sustainable fashion and its manufacture more accessible to both the public and the industry. We can't wait for the day when we don't have to talk about sustainable fashion any more – because ALL fashion will be sustainable!

British designer Richard Nicoll's collaboration with People Tree and Vogue *Japan.*

Growing up with Fair Trade fashion

❝ I think about the environmental impact of clothes – our future depends on us changing.❞

Jerome

❝ I didn't really know who made my clothes before I first modelled for People Tree. I tend to buy things from quite big brands but when I get the chance I will buy Fair Trade clothes. ❞

Tom

❝ We need more companies like People Tree, now more than ever; it is fundamental that we move to a new way of economic management. ❞

Luca

❝ I know that whoever made it got a fair price for their hard work.❞

Imogen

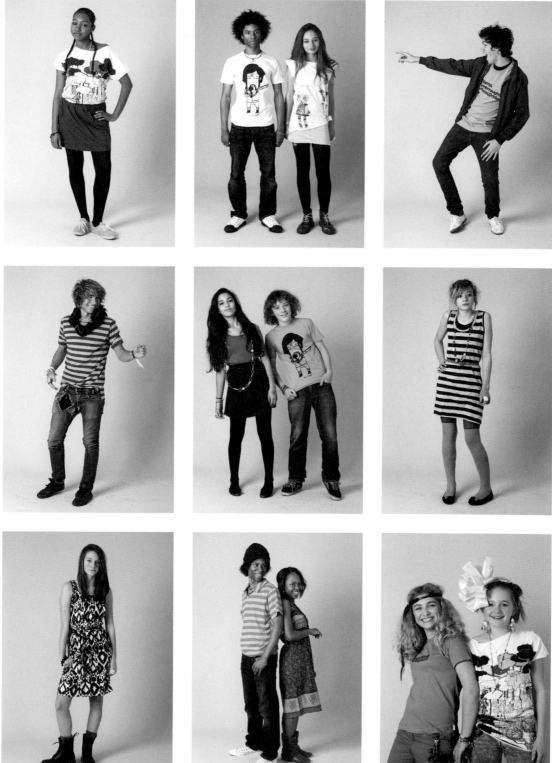

Resetting minds and hearts

Student Ben Corley's personal experience of Fair Trade fashion led him to think that business needs to embrace the concept of 'triple bottom line'.

When I chose to study Business Management in London, it must have partly stemmed from the desire to 'make the big bucks', but since then my aspirations have changed. Over the last two years I have begun to understand some of the problems society faces and – like most people with some entrepreneurial flair – I want to try and fix them.

A solution I stumbled across is a business of '3 Ps'. This is based on three principles – pro-people, pro-planet and pro-profit – and is often described as having a 'triple bottom line'. Conventional business maximizes financial profit and that is, in itself, a large cause of poverty and environmental degradation.

At 17, I visited Romania. I saw the chronic poverty in which whole communities were living but I also saw the most amazing answers to the problem. This was my first taste of social business.

I began working with DECE, which trained women to produce crocheted hats in their own homes. It gave them flexibility, independence and an income to support their families.

We got calls asking for 800 hats in six weeks but in a good month we could make only 200. In the long run, we could train up more women to increase our production capacity, but training takes time and orders have to be fulfilled. Buyers would ask for quick delivery and for lower prices, giving no commitment to long-term orders.

Later, when studying in London, I was encouraged to get in touch with a business whose work has inspired me. I wanted to travel with the CEO of People Tree, and that's exactly what happened. A few months later I was in Bangladesh visiting producer groups, learning how People Tree works with its suppliers. I wanted to see some of the challenges they face and also the positive impact they have on the communities they work with.

I saw the schools and daycare centres into which the profits of Fair Trade are reinvested. I saw the contrast between a garment worker living in the slums of Dhaka and another working for People Tree at their Swallows centre in rural Bangladesh. On the one hand there was a 14-year-old girl, working 12-hour days in a garment factory and living in a two-metre by two-metre room in the slums with three members of her family. On the other, a woman who worked eight hours, in good conditions, and whose children went to the Swallows school. This was people-centred production.

I'd love to take top business-people to see what I've seen – to reset their minds and hearts. I think we need to change large companies from the top down.

Maybe the seed of my first social enterprise has been sown – exposure trips for CEOs. Watch this space...

SAFIA MINNEY

WORKING FOR CHANGE

Alicia Reguera

Graphic designer, 25, from the Canary Islands.

I use all the design programs that I can and try to stay up to date with the latest trends in design and illustration. The most important thing is not to put limits on the project and always to be ready to adapt to new techniques and technologies.

Alicia's website: http://londinadas.blogspot.com/

Why did you decide to intern at People Tree?
When I moved to London I wanted to work as a designer in an ethical company with good values as well as style. People Tree seemed the most appropriate choice; their philosophy fitted with my goals and aspirations. I am inspired by the development work they do and very motivated by the team who head up the People Tree brand.

Had you heard about Fair Trade before?
Yes, of course, in the Canary Islands we are also concerned about it and are trying to raise awareness among young people and increase the number of Fair Trade products available.

I have always believed that commercial relationships between producers and consumers should be fair and that more affluent countries should help developing countries to establishment ethical and respectful business relationships. We should really invest in this and improve global society: everyone is entitled to a fair wage.

How are ethical and FT issues reflected in your work?
Graphic design can have a big influence on society and the commercial choices we make. Fair Trade is a positive initiative, and that directly influences my work. Knowing that we are working for Fair Trade means that projects are more rewarding; a positive attitude helps to get creative results!

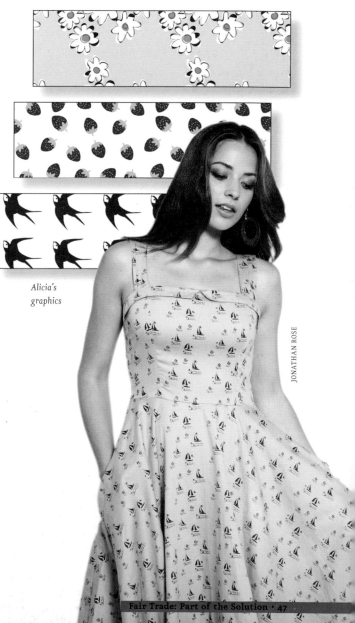

Alicia's graphics

JONATHAN ROSE

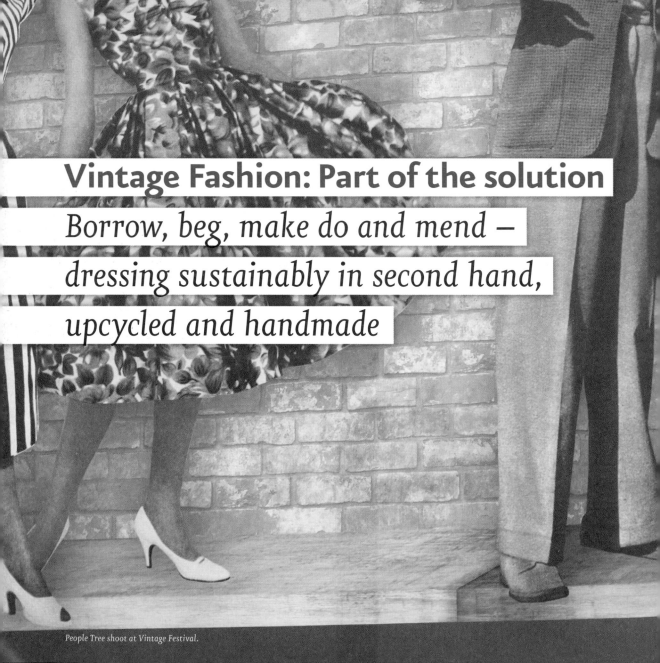

Vintage Fashion: Part of the solution

*Borrow, beg, make do and mend –
dressing sustainably in second hand,
upcycled and handmade*

People Tree shoot at Vintage Festival.

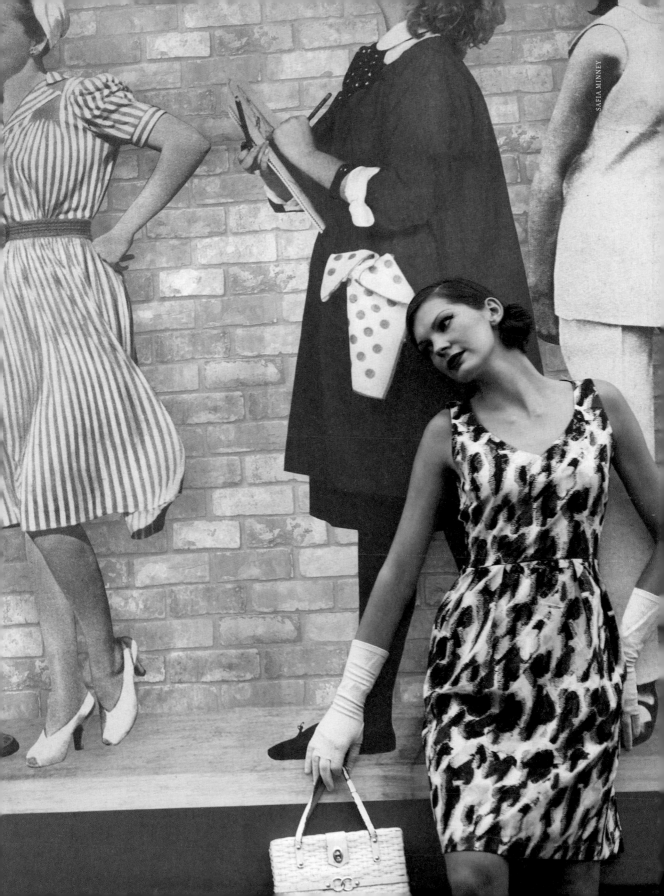

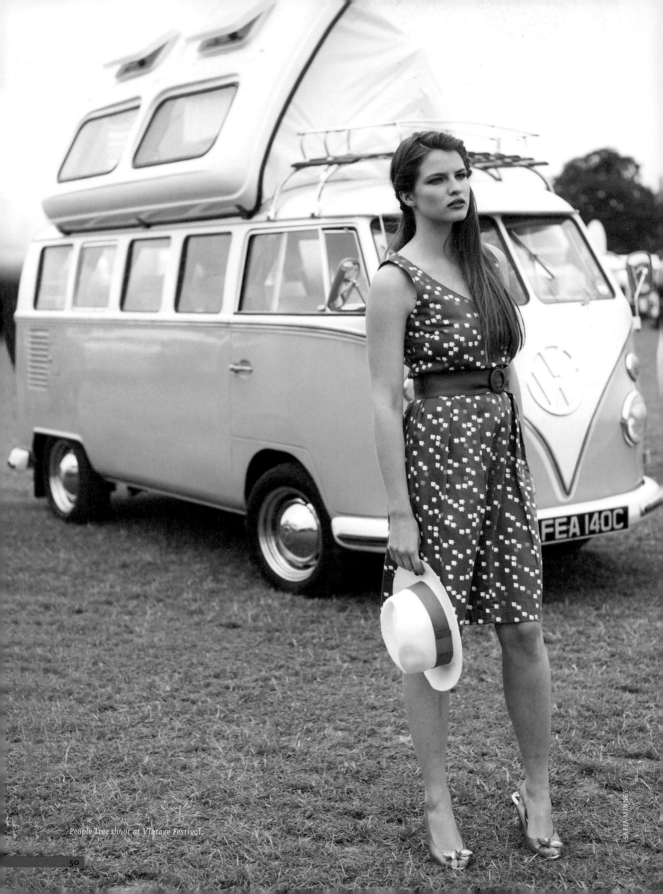

People Tree shoot at Vintage Festival.

Wayne Hemingway

Co-Founder of Vintage Festival

You're a social entrepreneur with roots in fashion. After selling Red or Dead, how do you want to do fashion differently? And why do you support TRAID?

We started on Camden Market in 1981 selling second-hand and customized clothing with a thrifty and political attitude. Red or Dead grew out of this background. We began campaigning for environmental issues by working closely with Greenpeace, by pioneering the use of hemp denim, and by our choice of manufacturing locations. Supporting a textile recycler like TRAID [Textile Recycling for Aid and International Development] is part of our DNA.

Do you think second-hand and vintage can be an antidote to fashion?

Second-hand and vintage are part of everyday fashion now – it's gone from underground to almost mainstream, and that has to be a good thing. Anything that prolongs the use of products makes sense.

Who do you most admire in the vintage and recycled fashion arena?

It's great to see the likes of Top Shop and Top Man selling vintage on the High Street. Oxfam continue to lead the way in terms of having the skills to identify 'cool vintage' during the recycling process. My favourite has always been Junky Styling.

How far has Fair Trade fashion come in the last 10 years?

When Fair Trade fashion started, design wasn't that strong. However, looking at companies like People Tree today, I'm really excited to see that an ethical brand is now commercial enough to sit alongside other high-street brands – amazing considering its supply chain is entirely Fair Trade.

What is the antidote to fast fashion?

The solution is to treat fashion as fun and not as competition. Fashion should be there to make you feel good and get you noticed, but should never be about 'keeping up with the Joneses'.

www.vintagebyhemingway.co.uk www.hemingwaydesign.co.uk

Vintage – get involved

WEBSITES:

The Frock.Com /
www.thefrock.com

Tangerine Boutique /
www.tangerineboutique.com

Ballyhoo Vintage Clothing /
www.ballyhoovintage.com

Vintage Kimono /
www.vintagekimono.com

C20 Vintage Fashion /
www.c20vintagefashion.co.uk

YOOX / www.yoox.com

Rokit / www.rokit.co.uk

Ooh la la ! Vintage /
www.oolalavintage.com

Beyond Retro /
www.beyondretro.com

VINTAGE BOUTIQUES

UK: Rokit, 101 Brick Lane,
London, E1 6SE
Tel: +44 (0)02 7375 3864

Beyond Retro, 58-59 Great
Marlborough Street,
London W1F 7JY
Tel: +44(0)20 7434 1406

Beyond Retro, 42 Vine Street,
Brighton, BN1 4AG
Tel: +44 (0)12 7367 1937

The Red Cross Shop,
67 Old Church Street, Chelsea,
London SW3
Tel: +44 (0)2 0845 0547101

Pop Boutique, 34 Oldham Street,
Manchester, M1 1JR
Tel: +44(0) 161 236 5797
www.pop-boutique.com

Vintage Fairs – UK

Frock Me! - Chelsea Town hall,
Kings Road, Chelsea,
LondonSW3 5EZ
Tel:+44(0)20 7254 4054
www.frockmevintagefashion.com

Hammersmith Vintage textiles
and fashion fairs
www.pa-antiques.co.uk

Australia: The Diva's Closet,
10/11 Young Street, Paddington,
Sydney, NSW 2021
+61(0)2 9361 6659

US: The Family Jewels,
130 West 23rd 633 6020
www.familyjewelsnyc.com

MAKE YOUR OWN & CRAFT VENUES
The Papered Parlour www.thepaperedparlour.co.uk

The Make Lounge
www.themakelounge.com/workshops

Here Today Here Tomorrow
http://heretodayheretomorrowblog.wordpress.com

I Can Make Shoes www.icanmakeshoes.com

KNITTING
iknit www.iknit.org.uk

Loop www.loopknitting.com

COURSES
Fashion and Textile Museum
www.ftmlondon.org/courses

City Lit www.cityandguilds.com

Crafts Council www.craftscouncil.org.uk

Channel 4
www.channel4.com/4homes/how-to/craft/
craft-courses-directory-10-09-28

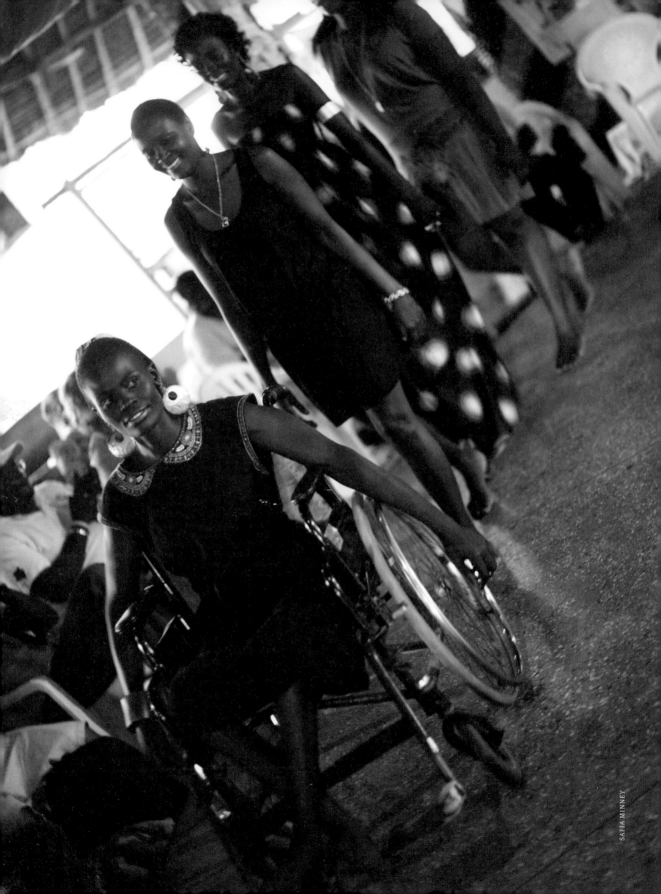

Media and mindsets

Fair Trade fashion show at
Bombolulu Workshops, Kenya.

CHRIS FLOYD

Caryn Franklin

The celebrated fashion commentator, long-time presenter and pundit with The Clothes Show, *who recently co-founded the project* All Walks Beyond the Catwalk *with Debra Bourne and Erin O'Connor.*

What success have you had with All Walks Beyond the Catwalk?

Younger women today receive more images of unachievable beauty in one day than their mothers saw in an entire adolescence. One of the areas that we've been working in has been 'sustainable bodies'. As an industry we could promote a more achievable or sustainable version of femininity. Women could see their beauty mirrored in fashion imagery.

Cutting-edge design can and should flatter all bodies. So we took a group of emerging designers – Mark Fast, Hannah Marshall, William Tempest – and matched them with a diverse set of models, young, old and curvy. And we said: 'We want you to create a sample garment that is about promoting your image for next season and we will take this to London Fashion Week.' As a consumer, you shouldn't have to feel that you are receiving a prescriptive set of ideals from the fashion industry about your body. Unfortunately, that is what happens because women don't see images of a broad variety of shapes in the fashion media – they only see the very young and very thin and inevitably very pale.

Mark enjoyed working with his model, Hayley Morley – a marvellous, curvaceous size 14 with a model agency called 12 Plus Model Management – so much that he put her on the catwalk and suddenly there was a huge interest from the press. This helped create a global interest in why All Walks Beyond the Catwalk felt the need for change.

Why do you work with fashion colleges and in education?

In our tiny little organization, we want the next generation of students to understand that they have a responsibility to address the messaging that they are creating for women around identity.

The most powerful way is through education – to give each person an understanding of their personal power and personal responsibility. To put them in touch with personal desires and goals I was in touch with 30 years ago because of the political environment that I trained in. I don't see that space now.

I see young creatives not trusting an instinctive power or desire but immediately internalizing a corporate need for their talents to be harnessed in pursuit of corporate goals – and therein lies the difference.

WITH THANKS TO KAYT JONES, RANKIN AND NICK KNIGHT FOR ALL WALKS BEHIND THE CATWALK CAMPAIGN IMAGERY

You have said you are part of the post-feminist movement. Was there more liberation and more of an idea about feminism in the Eighties than there is now?

Yes, it's like it never happened. I began in the Eighties, knowing that I was good enough. I now look at young women 30 years on asking all the time, 'Am I good enough? How much do I have to change to be good enough?'

What do you consider are the greatest challenges to new independent and ethical brands?

The hardest thing for an independent is that they have to compete in the marketplace against the giant brands. The consumer doesn't really make any distinction between a small independent, who knows all of their suppliers and their workers individually and who cares about the end product, and a massive corporate which just has an impersonal set-up and doesn't care. The consumer has prioritized cost and glossy veneer.

These powerful branding messages have become almost like beauty and fashion porn. We all get an amazing fix, a moment of incredible fantasy. We are taken out of our daily life and into something so beautiful and seductive – it is very powerful. We are in an environment where there are no boundaries on post-production so there don't have to be any truths.

Should there be legislation or guidelines around retouching?

Removing all wrinkles and imperfections has been done since time immemorial, using lighting and airbrushing, beginning with the Hollywood starlets. It has always been acceptable – after all, our favourite photos are the ones that catch us looking as we would like the world to see us. It is a tricky space to legislate. You are not allowed to misrepresent white goods but you are allowed

to misrepresent a body. There are scientific studies to prove that women are distressed by the amount of misrepresentation they are seeing around bodies and faces. It's gone too far.

The advertising industry has been aware that this is coming – the whole disenfranchisement of the consumer. Why are we women accepting it?

Young women have become destabilized. The corporate fashion brand has grown so huge, fashion can be a way to make enormous amounts of money through our insecurities. Nobody needs another beauty product, another dress, another pair of shoes. But if we can be made to feel, by association with the imagery, that we could be better, new and improved, then that's successful selling.

Women are vulnerable to suggestions from the fashion world that everything can be sorted out through appearance; the veneer is much easier to fix than the spirit or the soul.

When I go into colleges and talk, I am reiterating things that I learned from women like Susie Orbach 30 years ago. Today's women buy their own cosmetic surgery thinking liberation and emancipation is theirs. But are they questioning the culture that encourages them to do that in the first place? Thirty years ago I saw academics shouting at the tops of their voices about empowerment. It was just amazing. That was the culture that I inherited and in which I learnt what adult femininity was. Young women now don't have that space. They also have mothers who are equally fearful of what it means to be a woman getting older; women my age are receiving all these marketing messages from beauty companies about the terrors of ageing. Of course, in some ways women are not wrong to be wary – older women are certainly not celebrated in our culture. The job market will be harder for a start. When was the last time you saw a grey-haired woman on TV?

What is All Walks Beyond the Catwalk doing to help the fashion industry's predicament over size and ageism?

For our most recent campaign we worked with designers like Stella McCartney, Vivienne Westwood, Giles Deacon and other top names to create a fashion shoot featuring women of diverse beauty ideals – young, old, slender, curvy, light, dark. Rankin created huge portraits for us and we displayed them at the National Portrait Gallery, where 4,000 people joined us to celebrate diversity and individuality. There is a picture of Valerie, who is 67, in an Antonio Berardi dress – a fitted dress that showed her tummy. We wanted the tummy and the wrinkles kept in. Daphne, another model, is 80 – her skin is beautiful. Among the many features we created was a recorded conversation of our 'post production' decisions. We were looking to be as honest and open about what we were changing in the photograph. The skin and the shape of the bodies were untouched; the things we erased were unsightly inside seams or strange shadows on the clothes.

Imagine there were no limitations... What would fashion look like in five years' time?

There would be stores full of people who love and know their product. Fashion would be displayed on a variety of beautiful bodies so that every woman felt welcomed. Clothes would have a story that stretched back – pride at every point from every person who had been involved in making it. Celebrations of individuals and individuality would bolster self-esteem and then there would be no need for us all to create and buy so much STUFF!

Fashion as a culture is so busy trying to be cool and yet some of what it is doing is so *uncool*. It could recognize the amazing power it has to influence men and women's ideas about their bodies and it could create more inclusivity. It's actually a small shift in thinking but it could also potentially be lucrative.

We know that things are contradictory and hypocritical, we don't want to take skin-lightening drugs and tablets that stop us from eating... but who is going to be the whistleblower? Why doesn't someone change things – is it because the consumer doesn't respond?

As consumers we want a quick fix, so the whole corporate set-up promises instant results. All Walks will be working more slowly, as that is the only way we can work. We have just launched the All Walks Centre of Diversity in Edinburgh, which will lead the way in education by exploring and creating learning templates for colleges and universities to implement. We look forward to seeing how emotionally considerate practice will shape the way our industry operates when graduates take their ideas with them. Thankfully there are companies like People Tree who have managed to create a viable alternative in Fair Trade business, leading the way in creating sustainable change. Vision is everything, right?

With thanks to Kayt Jones, Rankin and Nick Knight for All Walks Beyond the Catwalk campaign imagery.

For more information www.allwalks.org

> **Fashion as a culture is so busy trying to be cool and yet some of what it is doing is so *uncool***

SAFIA MINNEY

Andrew Tuck

Editor of Monocle magazine, which attracts an international readership of free-thinkers who want more than reproduced trivia from the web, superficial news agency stories and images that pander to corporate values.

Tell me what appealed to you about Monocle magazine.
I came from a very traditional newspaper background where reduced budgets had a negative impact on overall vision and ambition as well as on the kind of stories you could write. At *Monocle*, we tried to reverse this. Let's create a magazine printed on the best paper, employing the most creative photographers and writing our own, original stories. Let's create a proper product that gives you news you can't Google and find online. We had 100-per-cent belief in our audience of globally minded people.

What advice do you have for young journalists who are trying to do things a bit differently, to break out of the corporate model?
I wrote to everyone I could think of and asked for an internship. I was very fortunate to be taken on at *Time Out* magazine; I worked crazy hours for six months (whilst supporting myself as a barman and waiter) and then eventually got a paid job.

An internship lets you understand how a business works. It's good discipline – you learn how to be in an office environment, how to fit in, what a working day is. You must never think it's too humble to make the coffee – and don't think you will be writing a 20,000-word piece on your first day!

You must be prepared to step back and do something very basic to get in the door... you might work on reception where you can show that you are organized, be the face of the company and look after people the minute they arrive in the building. If you do that well, people will start giving you stories to do.

You need to have ambition, talent and the right attitude and determination; this can often be more important than a huge amount of experience.

What do you think about the future of journalism?
Because of our fascination with celebrity culture and the cutting of budgets, a lot of people say journalism is dead. BUT, you still get amazing pieces of investigative journalism in some newspapers. You can't stop young people wanting to be great reporters. The recent death in Libya of the photographer Tim Hetherington illustrates this point. At a young age he was living in Africa putting himself in the middle of civil wars and making an ongoing commitment to stories. That was incredible. He wasn't employed by anyone – he operated independently.

The Monocle working on their radio and TV shows.

Journalists have a responsibility to their readers to create genuine, deeper knowledge and awareness; they have the power to galvanize their readers into positive action and change...

...and we must never underestimate our audience. There was a time when bloggers, twitter, social media sites shook us all – speculation and gossip become news! However, things have settled and quality reporting has survived. People need to know what is true and genuine.

The same applies to advertising images and models. People can accept diversity – sex, age, size, style – if it is presented with confidence and integrity.

What are your views on the integrity of the fashion industry?

It is wrong that for some, fashion is about throwing away cheap, mass-market clothes every six months and buying another look. This is pure waste. At *Monocle*, we deliberately don't shoot things that we think will be boring in three months – we are trying to get people to buy clothes that will stand the test of time.

What is interesting is that many hugely successful luxury brands started off as small artisans working in local environments. They have not forgotten their origins and the principles on which they have made their fortune: craftsmanship and quality. For example, you can take a Hermès handbag that was made 40 years ago back to them and they will re-stitch it for you. This is both sustainable and ethical. They haven't forgotten their origins as a bridle-maker. Top brands – those that would sit in the LVMH stable – are very interested in telling you about where and how things are made. They are really proud of it.

On the other hand, you find, in the middle market and downwards, there is no interest in provenance. Garments are untraceable, people actually try to obscure where things are made because it is all very suspect and immoral – a T-shirt for £6 ($10) – without doubt, someone has been exploited and is suffering somewhere along the chain! This is being covered up and hidden. I know of a big European brand, who explained that they moved production out of China (because the Chinese labour force are now too organized and expensive) and into Bangladesh, where they can still profit from the exploitation of the workers. However, they anticipate that within 10 years the Bangladeshi workers will have found a voice – in which case they will move production to Africa!

http://monocle.com

Adam Harvey

The account manager at one of London's largest creative production agencies asks how much is too much.

Can you describe your job?

I am an account manager for Masterpiece – a creative production agency. We cover everything from retouching to page make-up and typesetting. We also have a photography studio. As account manager, I take care of a brief, make sure that people on the floor are clear about instructions and style, and then see the job all the way through to press.

How did you get started?

I was interested in graphic design, logos and packaging. I didn't study at college but bummed around, had a few jobs and then became an electrician. I hated it and thought 'I've got to get my act together'. Luckily, I knew someone at Masterpiece who got me in. I was 22 and went in right at the very bottom. I was keen, worked hard and was careful not to get on the wrong side of anyone.

What are your views on the manipulation of images for magazine features or advertising?

Early on in my career, when it was a manual process, it was very difficult to manipulate an image. Even when manual retouching was later replaced by digital retouching, we weren't changing body shape like we have done in the past decade, it was just a case of colour correcting. Now, with Macs and Photoshop, it's all so easy – there is the possibility to completely re-sculpt a whole body. You can make a larger

lady appear slim. Personally, I think it is pulling the wool over people's eyes. There should be boundaries. I have no problem with colour correction to skin tones and smoothing out blemishes and moles: that is fairly standard.

Do you think we could introduce a kite mark or standard to show how much retouching has been done to an image?

I think there is potential for one, but I think it will be difficult to govern where that line is, as everyone will have a different opinion about it. For example, I don't think the weeklies have a great deal of retouching in them, as a lot of it would appear to be pap shots or phone shots.

Does it worry you that young women see images that have been highly retouched?

Straight away I think about the 12- or 13-year-old

Adam before retouching...

girls who aspire to impossible body images. They lose their childhood, they want to grow up too fast. This is so damaging at such a young age.

We also have people in their thirties or forties reading magazines full of images of twenty-somethings. Don't you think fashion editors and picture editors have a responsibility to their readers?
Yes, they do, but at the same time, everyone likes a bit of glamour. The readers also have a responsibility to differentiate between fantasy and reality.

There are videos shown at school now to help make teenagers more media-savvy – they learn about the process of retouching and see that it creates unnatural, unattainable images of body and beauty. Do you think that's good?
Yes, I do. Although they do want a tidy-up of the hair line, skin tones, wrinkles and so on. We used to spend hours on retouching magazine shots in the past – now we will perhaps spend 25 to 30 minutes on each image. Maybe things are turning full circle, back to the days of manual retouching and a more 'natural image' – in inverted commas!

We're going to take a photograph of you wearing your favourite People Tree shirt and retouch your image. Anything is possible – so what would you like to change?
I think probably my build. This is quite difficult, but I would quite like to be a bit bigger – not in terms of height, because I'm 6'4", but bigger-boned. I'm too slim. Just make me a bit more 'manly' – more rugby player than high jumper!

www.masterpiececreate.co.uk

…a 'natural' retouch…

…Adam with a lot more work.

MASTERPIECE PHOTOGRAPHY STUDIOS

PRACTICE AND THEORY

Andreas Pohancenik

From typography to 3D sugar, Austrian graphic designer Andreas Pohancenik on how he forged his own path – and why design matters.

I grew up in the Eighties in Vienna – a city of grand architecture and grander cakes! My mother owns a small perfumery in the centre of Vienna that has been in our family since 1948. Ever since I was small I would hang out in the shop and it was there that I first became interested in fashion and design. Perfume packaging can be very imaginative, and it was interesting to me to observe all of these objects changing colour and shape with the seasons, like flowers.

I came to London to study Communication Design at Central St Martins [College of Art and Design]. Working in a new city alongside illustrators, fashion designers and animators, I thrived on all the different creative influences around me.

Setting up a graphic design studio in London is not easy. The first year I nearly lost faith – there were so many false starts and 'opportunities' that turned out to be more pain than profit. The time and effort put into finding jobs swamped the actual creative side.

Things started to improve in the second year. It was a slow process. One has to have drive and the ability to put aside personal needs – free time, holidays, personal relationships, these are all going to take second place (or third or fourth) to a design job that needs to be on time and to budget, and completed to the highest standard.

Fortunately, there are some jobs that make all the effort worthwhile – like working with People Tree. Initially, I redesigned their logo and clothing tags. Now I design their catalogues. The very first one I designed was Summer 2010, introducing People Tree's collaboration with Emma Watson. The designer needs to pull all the elements together into a coherent visual whole. At the same time the catalogue evolves with each

A Practice and Theory publication.

PRACTICE AND THEORY

Edible invitation:
3D sugar invitation card

provocative tool. My response was to craft the exhibition graphics entirely out of sugar, and I designed an exhibition catalogue of sugar and wafer paper that could be consumed at the end!

Looking to the future, I'm keen to combine 2D and 3D design, creating creative spaces as well as printed pages. With my partner, I opened a space in central London that will exist as something between a gallery and a workshop; we hope to encourage creative experimentation and debate about how design intersects with human lives through history, the present and the future. By bringing together designers from all sorts of disciplines, perhaps we can learn more about the role of design and its possibilities.

Andreas Pohancenik is an Austrian graphic designer. In 2003 he moved to London, and received a Masters degree with distinction in communication design at Central St Martins College. Working in Vienna and London, he set up the design studio Practice and Theory. He was recognized for Typographic Excellence at the ISTD Awards.

www.practiceandtheory.co.uk

'Product labeling by Practice and Theory.

season and the layout needs to reflect that new content, so it's different every time.

Lately I've returned to some of the things that first inspired me about design. I've always wanted to make design that matters – whether it's through designing for companies that can change the way we work and buy, or designing for a cultural institution that can inspire and inform. I made the graphics for an exhibition at the Museum of Applied Arts in Vienna. The exhibition showcased creative responses to Adolf Loos' famous tirade against 'embellishment' in design. Loos argued that designing trendy things was a waste of creative effort and resources, and plumped for the classic, never-out-of-date school of design. The exhibition showed both sides of this, suggesting that embellishment can be a

Lovebirds

Lovebirds is a new design studio in London started by Chris Love and Victoria Avery.

Chris: I studied Eco-Design at Goldsmiths College, where I explored ideas around the social and environmental responsibility of designers. My professional career began at Maharishi [an influential British Fashion house] aiding in the launch of their e-commerce ventures and contributing as a junior graphic designer. The innovative style of the creative director there, Hardy Blechman, is a great inspiration to me.

Victoria: I gained a first-class honours degree in Multimedia from Bournemouth University. During one summer I did work experience at a small marketing agency and they offered me a job after graduating. In my spare time I would work on my design portfolio as much as possible. From there I was offered a job at a top 30, integrated ad agency, where I gained a great deal of experience as a 'creative brand guardian'.

How did Lovebirds begin?

Victoria: I started freelancing two years ago. Chris and I met during my first contract and we decided to form Lovebirds after winning a competition to design a window graphic for a London café chain.

Chris: Now we both work full-time and run Lovebirds in our free time. Our first studio project was to design this 10th-anniversary graphic for People Tree [see facing page].

What advice would you give someone trying to break into the creative industries?

Victoria: I'd encourage them to build a portfolio – even without commercial briefs you can still demonstrate your skill and passion by including personal projects. I love typography, so sometimes I'll take a famous quote and craft the type. Some designers will look at an existing campaign and create their own interpretation. For example, they may see a film poster and after watching the film think, 'I'd have approached that in a different way'.

Chris: It can't be said enough how much your determination, hard work and self-belief are essential aspects for building a business.

In the future, what percentage of your work will be with ethical or social business?

Victoria: We'd like to make it 100 per cent of what we do but we also need to be aware of financial constraints. Companies have to prioritize budgets but there are always ways of making design more ethical – for example, Lovebirds were asked to design a Christmas card and one route we presented was a card that you would plant, rather than discard. It tied in with the client's message of nurturing businesses and the plant was a reminder of the company long after Christmas. As a freelance it's great to see how bigger businesses embrace ethical issues.

Chris: We are seeing a huge shift in the way businesses are operating. Clients increasingly want to be involved with projects that are Fair Trade, ethical and sustainable. It's in their long-term interests to look after people and the planet. Attracting capital into ethical and sustainable projects is one challenge for today's designers. The other is taking great ideas and using them to improve their own lives – after all, that is what good designers do.

www.lovebirdslondon.com

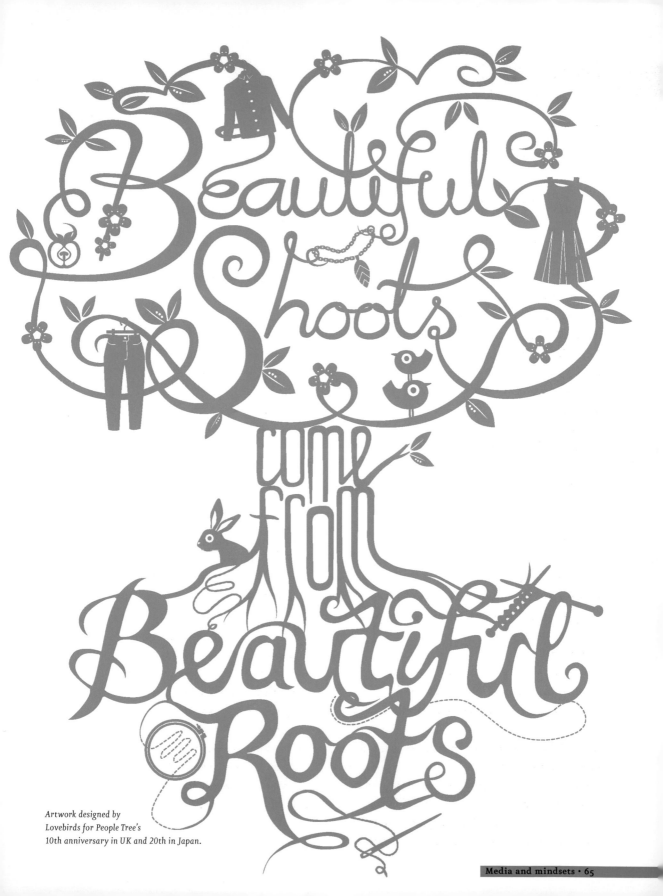

Beautiful Shoots come from Beautiful Roots

Artwork designed by
Lovebirds for People Tree's
10th anniversary in UK and 20th in Japan.

Geoff Wilkinson

Founder and producer of the hip-hop-jazz group Us3.

As a musician and producer, how do you use music to promote awareness of social justice and environmental issues?

I've always believed that music can be a great force for social change. Throughout history, this has been achieved by artists tapping in to public perceptions and concerns, and articulating them to create a catalyst for change. I try to influence the mood and context of the message the rapper is trying to get across by talking to them a lot before recording. I've usually got a theme in my head for each song and I like planting the seed in the lyricist's head, then watching that seed grow.

How did you get into music and what are the opportunities for talented musicians today?

I started DJing when I was a student, then got into organizing and promoting gigs and booking bands for the Jazz Café in London. I was a 'bedroom musician' until I got a job managing a recording studio. When I started producing I must have been in every record company's office trying (in vain) to get a deal! Eventually I snapped and put out a 12" white label myself, which was rare at the time. That got me a one-off deal with a (then) small indie label called Ninjatune. That release drew attention from Blue Note, which led to me getting signed to their parent company, Capitol Records in LA.

The music industry has changed beyond all recognition, and I honestly would not recommend it to anyone as a career path. Illegal downloading has decimated sales. You have to be very thick-skinned, very hungry and very talented to survive.

How did you come to know and support People Tree?

I first met Safia when we played the Blue Note in Tokyo in February 2002. I remember it was refreshing to have an interviewer really focus on the album I had just released [*An Ordinary Day In An Unusual Place* was the third Us3 album, released in 2001] and Safia really grilled me about the socio-economic themes on it. Good interviewers should make an artist question themselves. I felt Safia was a kindred spirit and that made me want to find out more about the work that she was doing.

A 'people tree' is such a great metaphor for the work Safia and the team do – it is such an empowering organization. Working directly with people in countries like Bangladesh is having a direct positive effect on their economic well-being.

People Tree is fighting for our environment as well by actively encouraging the use of organic cotton. I have a degree in Geography, and environmental issues have always been very important to me. It has always made me angry the way multinational corporations treat the people and environments of so-called Third World countries just to maximize profits. Geography is about the relationship between humans and the Earth, a relationship that should be nurtured rather than exploited for short-term gain. People and the Earth are important to me and they should both be important to everybody out there.

www.us3.com

Mark Edwards

The photographer and founder of the Hard Rain project, Mark has concentrated throughout his career on humanitarian and environmental issues.

The Hard Rain project has inspired a lot of people to look into humanitarian issues...
Photography does a lot of things – it sells toothpaste, records scientific experiments and brings humanitarian issues to life, to name but a few. It's a language but it communicates to everyone. What inspires me are the issues I photograph. I've only photographed environmental and development issues, so I have worked in a small corner of the profession.

What are the key social and environmental issues?
Aligning human systems and natural systems.

How does the Hard Rain project raise awareness of issues and engage the public?
All the great challenges of our time: hunger, habitat destruction, overconsumption, pollution, climate change, war, loneliness and despair, tumble together in Hard Rain – as they do in the world. It's overwhelming.

Generally speaking, global problems are delivered to us in bits and pieces, pigeonholed and sanitized by academics and expert commentators. But the parts don't reveal the vitality, the urgency or the extent of the crisis we face.

Making human progress sustainable will require tough leadership at the top, which will in turn require tough leadership at the grassroots to stiffen the courage of political and business leaders. The companion exhibition, *What'll You Do Now?*, responds to requests by thousands of visitors and curators for an exhibition that presents solutions to the problems illustrated in Hard Rain.

We have most of the tools needed to reinvent the modern world so it's compatible with nature. We have a choice: invest in a sustainable world or watch the hard, hurting rain sweep across the planet, eroding hard-won gains and diminishing nature's diversity.

Do you have any advice for someone interested in starting a career in photography and the media?
Only do photography if you are absolutely determined to do it as a job. There is no security and only a few make a living, so it really has to be something you do because you have no choice.

www.hardrainproject.com

Viewing the Hard Rain exhibition in the park – and one of Mark's classsic photographs, of people living on the street in Mumbai, India.

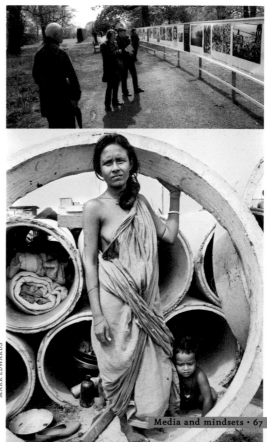

MARK EDWARDS

Photographer **Miki Alcalde** *charts the circuitous route he took before finding work that matters to him and to the world.*

'You have to get a visa tomorrow and fly to Bangladesh the day after,' my agent said on the other end of my Indian cellphone. It was my very own lucky strike – and nothing but destiny at its best – that another photographer was supposed to land in Dhaka to photograph Safia and People Tree's work in Bangladesh, but had flown to Dakar in Senegal by mistake. Little did I know that I was about to meet someone who would instantly become my mentor and best friend.

I was 27 and living the dream of working as a photographer in Delhi for a big agency. It was a dream that had proved to be not quite what I had expected – taking portraits of your average corporate CEO is not why I picked up a camera and found myself in love with photography in the first place. Something had gone wrong along the way; I felt I had been short-changed.

Five years before that, I was travelling through the Middle East and Asia with a tiny backpack filled with 100 rolls of black-and-white film, a pair of jeans, two t-shirts, two pair of socks and underwear, a sweater, and Nietzsche's books.

This was all I needed for months on end. Back then, $100 lasted more than a week. I roamed the streets of one country after another, day after day, camera in hand, watching and searching and walking, and endlessly looking around for a picture that could tell the rare poem that was happening right before my eyes, in an instant that often slipped away. Those were the days (years!) when travelling and photographing was all I wanted to do with my life, and so I did just that.

But love stories end the same way that rainbows suddenly disappear at the sharp end of a rainy day: there came another light, another midnight, another hour. And so, leaving 'street photography' behind, I flew to Africa to wander around and let stories come to me, asking to be photographed. I entered Sudan from Egypt and travelled south, with no fixed idea in mind. Two weeks in, there was nothing for me to do there, so I crossed the Sudan-Ethiopia border overland, and found myself at a very shady one-road town at dusk. I ran for shelter in the first place that looked like some kind of hotel, only to find out a little bit too late that it doubled up as a brothel;

but it felt ok, so why not stay? Soon after, a young and charming prostitute invited me to her room just to hang out and, while she was putting on her make-up to start her shift, I began photographing her. It felt as if there was nothing wrong with me being there, silently staring at her through the viewfinder of my camera. I was there, but I wasn't there. The walls of her tiny shack had posters of her favourite Indian movie stars; there was something about the mood, those walls, and the mirror she was holding in her hand. I knew well how Ethiopia was painfully dying from the AIDS epidemic and decided, right then, by her sharing that innocent yet intimate moment with me, to spend the next few weeks documenting the country's suffering as I travelled through it, visiting hospitals and centres for the dying. Years have gone by now. I never saw Ethiopia's prostitutes again, or the dying infected mothers, or the dispossessed; I won't ever know of their fate. My work has not done anything to bring the slightest improvement to their lives or alleviate their problems.

In Bangladesh, I turned my camera towards the poorest of the poor: farmers who live on plots of land that exist in the middle of the country's mighty rivers, on islands that are quickly being eroded and disappearing due to the effects of global climate change. Nobody outside Bangladesh knows, but if everyone could

Miki jumps for joy in a mountain of organic cotton
PHOTO: SAFIA MINNEY

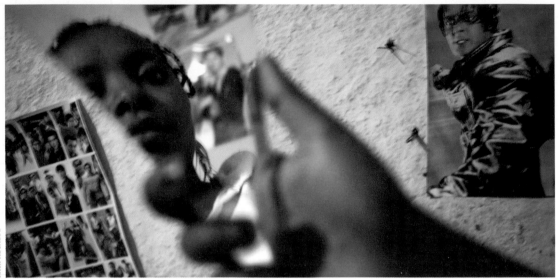

MIKI ALCALDE

spend just a minute there, watching a family working on their field while the very land where the crop is being harvested is washed away by the river, they might stop to wonder why this family in one of the poorest countries on earth has to suffer the consequences of our developed world's unnecessary excesses...

But not everyone can be there, and that is why photographers go there. Although, the truth is, my pictures from Bangladesh hardly have any real value. The families living on the river islands have by now lost all their crops, their futures; the husbands are already rickshaw pullers in the streets of Dhaka. Several thousand people in Australia, Italy, Spain, Britain and the US flipped through the pages of a glossy magazine and got their somehow-compulsory, agenda-driven Sunday dose of 'world issues'; then turned the page, didn't consider changing their lifestyles, and so the cycle continues.

So, among the ruins of my realization, there came

another light, another midnight, another hour, and for the past three years, I have had the joy of travelling with Safia and witnessing first hand the difference that Fair Trade makes, photographing People Tree's producers in India, Nepal, Bangladesh, Bolivia and Kenya, and experiencing first hand how something we as consumers do in the so-called 'developed' world can directly affect someone's livelihood in these countries. For instance, Fair Trade takes entire families away from Dhaka's inhuman slums (where millions are forced to live, working for the mainstream fashion labels), back to their villages, where they can work and live, comfortably and with dignity, making Fair Trade clothing.

The next time you open up a People Tree catalogue and, beside the picture of a model wearing an outfit, you see the picture of a local woman happily weaving the fabric, think of her as a real woman, just like you. Her smile tells the story of someone who is able to earn a fair living,

People Tree ambassador Jo Wood photographed for Marie Claire by Miki Alcalde.

in a country where that is considered to be a rare luxury. She has pride and walks with confidence. Safia and I are likely to have had tea at her home after photographing her; to have chatted with her lovely family and seen how strongly she stood there in front of them; to have seen how her children and her husband look up to her. She is thousands of miles away from you and me, but that distance is reduced to nothing when we're wearing the fabric she just weaved with her own hands.

If you want to become a photographer, you could try my route. I started working in a picture library in New York, as I come from a small city in Spain where few opportunities to pursue my passion for photography exist. I offered myself as an intern, but luckily got a paid position. I instigated a competition every Friday where those of us who worked in the picture library offered up our best photographs to be judged by the agencies' photographers. As I won more often than the guys who had a photography degree, I gained confidence and left the agency to travel the world and photograph everything that caught my attention along the way.

Today, photography is still my passion when I use it for social change, but it funds my other passion too: to keep nurturing my free will.

She is thousands of miles away from you and me, but that distance is reduced to nothing when we're wearing the fabric she just weaved

migalc@gmail.com

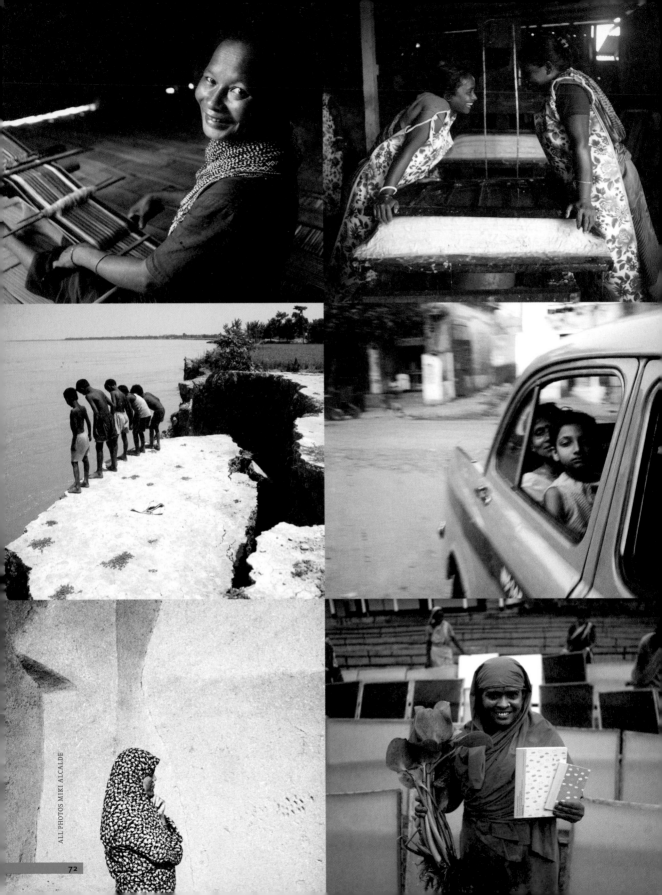

ALL PHOTOS MIKI ALCALDE

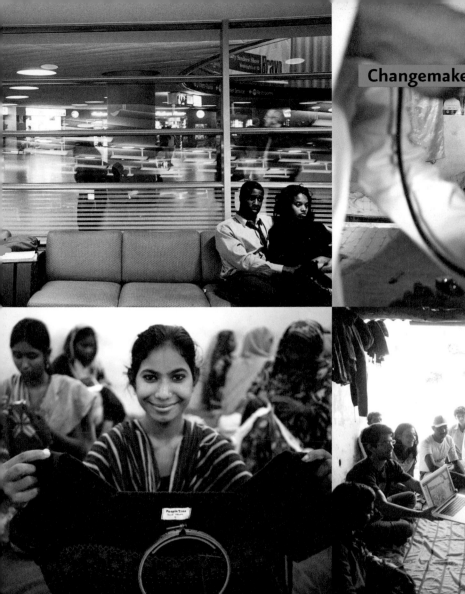

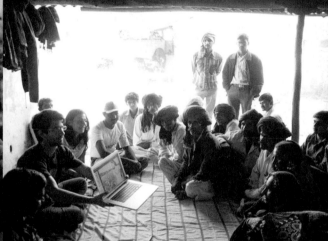

Styling a new industry

Experimenting with new hand block print design
at Kumudini Welfare Trust, Bangladesh.

Hand embroidering at Swallows, Bangladesh.

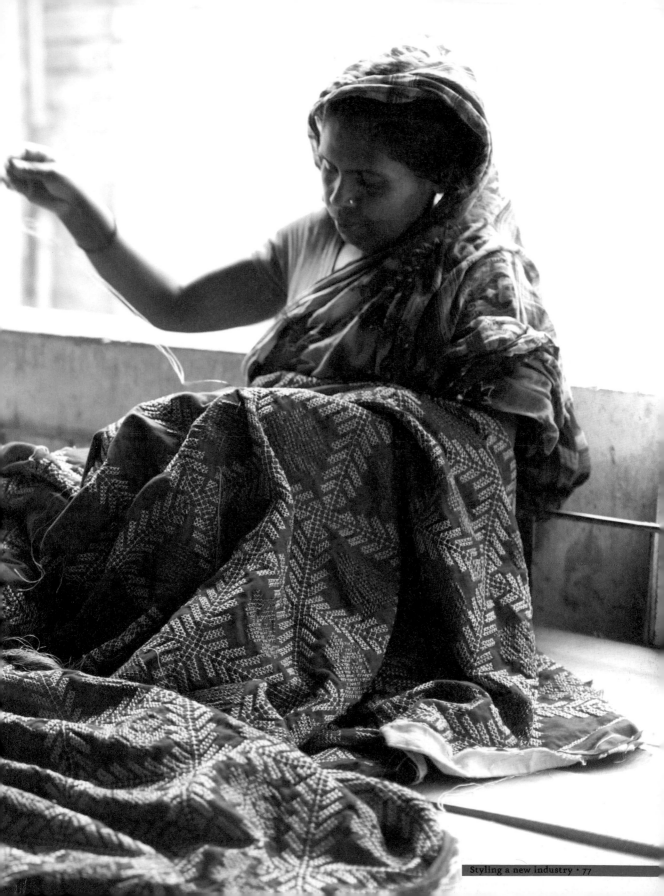

When **Summer Rayne Oakes** was told her hips were two inches too big, she took the fashion industry head on.

When did you realize there are different ways to do fashion and modelling?

I wanted a more creative way to get social and environmental issues out to a wider audience and realized that the fashion industry was a new and fresh industry in which to pursue that. Modelling was a way for me to enter the industry and learn more.

Did you model for ethical brands in the beginning?

Early on I began working on a sustainable design and avant-garde fashion project called Organic Portraits and started modelling with under-the-radar, independent eco-fashion labels, many of which are not around any longer. Since awareness-building was a big part of what I wanted to do, I began writing articles for magazines and compiling lists of ethical brands around the world. I think people began connecting the dots. I hope what I do can show people – both inside and outside the fashion industry – that you can align your values with what you do personally and professionally.

The fashion industry isn't known for its values...

No, you're right. When I signed with my first agency I told them how passionate I was about environmental issues and that I wanted to align myself with brands that shared that ethos. They puzzled over that for quite some time. The extent of fashion's values was that you didn't endorse fur or cigarettes or alcohol. Or that you did some charity on the side.

How does that tie into health, diversity and wellness?

Strangely, it's all connected, in my eyes. It's funny, because I remember speaking to my first agency about my environmental pursuits and my agent looked me squarely in the eyes and said, 'You know,

80 per cent of the jobs won't be available to you because your hips are two inches too big.' I was utterly astonished. Here I was wearing my heart on my sleeve, saying what I wanted to do with such conviction – and he drops a bust-waist-hip comment! It was so short-sighted.

I told him: 'If you think for one second that two inches on my hips are going to stop me from doing what I want to pursue, then you are sadly mistaken.' I meant it. I didn't mean I was going to lose the weight. I meant that the fashion industry would be too small to contain the heart that I had behind what I wanted to accomplish in life. I would stay true to myself and my course. I felt he was personally supportive but so short-sighted. But he learned what he learned by an outmoded system.

So are you a proponent of health and diversity in models as well?

Indirectly, though it hasn't been my principal mantra. For one, I signed with an agency (NEXT Models) that truly understands diversity (size, shape, colour) and personality. I'm quite athletic and curvy for the typical model – and have the platform that I have, which is unique, so I'm glad to be with an extended family of people who get that.

What do you think about the way the fashion industry talks about issues like diversity and environmental issues?

The way the overall industry communicates 'diversity' in the fashion industry is literally the same formula that the fashion magazines use to talk about 'green' issues.

MARCO CECIC-KARUZIC

It's a subtle distinction that needs correction. Think about it: how many 'black' issues have you seen? *Vogue* has done one, *V* did it, so does *Vogue Italia*. When photographers art-direct with a model who happens to be considered 'plus size' they almost feel compelled to put her right next to a supremely thin girl, or the article is all focused on weight, weight, weight. Then you have 'green' editions of magazines (much in the same way you have 'black' editions). When you do that, you insidiously feed the idea that 'white' and 'black' are so different. That a 'green' way of life is so unrelated and different from 'conventional' living. I even struggle with the term of 'The EcoModel', you know? There is a way I believe one can celebrate all forms of beauty – and green lifestyles – without overstating the obvious. It needs to be a much more subtle, civilized, charismatic and consistent approach. It shouldn't be confined to one celebratory issue one month out of the year and left off the table for the other 11 months. But that's changing as well. The fashion industry is starting to respond.

Which brands have you worked for?
I've worked with a number of brands over the years. I work with Payless ShoeSource on a more environmentally preferable shoe line called zoe&zac, Portico Home on an eco-conscious bedding and bath line, MODO Eco Eyewear and Aveeno Smart Essentials. I've also worked with labels like Levi Strauss, Deborah Lindquist, Linda Loudermilk and a host of others. I was invited by Oxfam and People Tree to join a panel discussion at the WTO Trade talks Fair Trade event in Hong Kong and modelled in what was probably the first Fair Trade fashion show politicians had ever seen. It was fun. I supported People Tree as a model when it was a tiny brand.

What are you doing right now to mainstream ethical and Fair Trade fashion?
I've been working on sustainable design, founding Source4Style, which is a B2B online marketplace that allows designers to discover and source more sustainable materials and services from a network of global suppliers, including artisan groups from around the world. I started the business with my best friend, Benita Singh, who has an incredibly dynamic background in Fair Trade sourcing. Together we saw the need for a scalable solution to sustainable sourcing.

What is the difference between the US and UK ethical and Fair Trade fashion industries?
The US in general, I feel, is more commercial, whereas many brands in the UK are focused more on an emerging niche – a very targeted consumer. In the UK, Fair Trade fashion is more advanced in the industry and consumer mindset – it hasn't captured the minds and hearts of the US consumer yet!

http://source4style.com
http://www.summerrayne.net

JUNIOR AGYEMAN

Eleni Renton

Director of Leni's Models Management.

You launched Leni's as the first ethical model agency. There's a whole host of issues around the physical and psychological health of models, size zero and ethnic diversity – how bad is it?

Since we did our first event in 2008, the industry has changed massively. When I first started the agency, people said 'Are you crazy? You can't go against the whole industry'. I think that people never felt there was a choice. Now people are realizing there is another way and that seems so positive.

Why were you so passionate about changing the industry?

I was 15 when I got scouted at the Clothes Show. My body hadn't developed, so by 16-17, I had grown no taller but outwards, which is fine, but obviously not when you're modelling. I appreciate we are not a plus size agency at Leni's but I feel we have a healthy body image. Our girls are size 8-12, 5'8''-5'11'' – a few girls may have to work at it but none of them

need to starve themselves. You know there's something wrong when women are 5'11'' with a 32-inch hip.

Men are definitely more affected, too, nowadays. Boys as young as 11 are putting themselves on diets – we work with counsellors and they tell us boys are more affected by eating disorders than women now. The fashion and beauty industry have realized that men are a growing market and with that comes a persuasion about how they should look which women have had to deal with for years.

I think the next thing we need to tackle is retouching. Retouching has its place but I think it has become almost obscene – a false, unachievable sense of beauty which isn't making anyone happy. The size issue needs to become more realistic for women and men.

How do models react when they see their images retouched?

It can definitely have a scarring effect, because they question everything. Why did I need that doing? What's wrong with my arms? I think there's a difference between your eyes being enhanced because there's a greenish background, and having your hip thinned down – and you can see these girls thinking 'actually, what's wrong with my hips?'

I'd like legislation on retouching. I almost sit in the centre really, in that I think retouching should happen in some circumstances. For example, if a girl is booked for a beauty shoot and she has a pimple on the day of the shoot then of course they would retouch that out – I understand that! But I feel that it's almost got out of hand. There was that Lancôme mascara ad that Julia Roberts did – I mean, preposterous! You'd think that the consumer would know that, but you'd be amazed at how few people do. Retouched pictures should come with a guideline, almost like a kite mark, about how

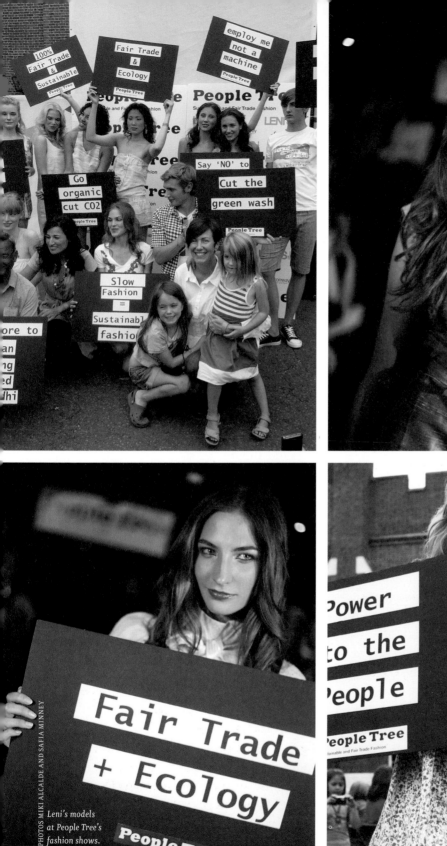

Go organic cut CO2 — People Tree

Slow Fashion = Sustainable fashion — People Tree

100% Fair Trade & Sustainable — People Tree

Fair Trade & Ecology — People Tree

employ me not a machine — People Tree

Say 'NO' to Cut the green wash — People Tree

People Tree
Sustainable and Fair Trade Fashion

Leni's models at People Tree's fashion shows.

Fair Trade + Ecology — People Tree

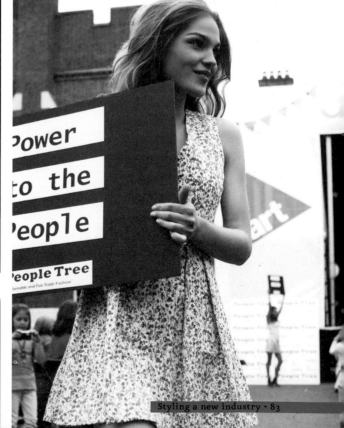

Power to the People — People Tree
Sustainable and Fair Trade Fashion

much it has or hasn't been retouched. Like in shampoo advertisements – when they say they've used hair extensions.

How could the health of models be promoted?
Models arrive for [London] Fashion Week on an overnight flight knackered, have fittings sometimes until the early hours, then they turn up at the show and what have they got to eat? – a box of pastries. It would be easy to have healthy food that you want to eat and enjoy. We are asking models to be slim and feeding them rubbish. It becomes a self-fulfilling prophecy.

I think they should issue guidelines for Fashion Week outlining the need for healthy food at shows, and check models' BMI [Body Mass Index] to be sure they're healthy. Clients and advertisers could do the same.

One of our clients measures our model prior to each shoot to be sure she has a plus 21 BMI. I think that's a great attitude. Agents should be managers and take a longer-term view. Our product is live, it's a human being and we've got to protect our models.

In your experience, what's the worst that could happen to a 14-16 year old who starts modelling?
We only have girls from 17, and I think 16 is too young, but I have known 14-year-old girls go to Japan and China from Brazil and live there by themselves, which is mind-boggling. It's a fun industry, but there is a dark side. I don't mean that in a big scary way, I just mean beautiful girls and men: it can quite easily be an abuse of power. The old casting couch – I'm sure it happens in lots of industries but definitely wherever one person ultimately has all the power.

I don't know why anyone selling clothes to women in their twenties needs a 14 year old to advertise them anyway – it's bizarre. I don't think that lots of the issues we saw years ago – drinking, taking cocaine and so on – have gone away in some areas of modelling, because you don't change the beast: young girls get taken in by things. It's seen as a glamorous life – first they're throwing champagne at you and before you know it they're buying you handbags. From the outside we look at it and it's all a little bit seedy but, you know, imagine you're a 14-year-old girl who thinks 'my God, this is what it's like, this is what I have to do'.

Are the catwalk and campaigns becoming more ethnically diverse? What needs to change?
Interestingly, I saw a show the other day and they said that the proportion of images of mixed-race models is approximately 33 per cent higher than what exists in the population. However, black models are disproportionately lower. It seems the Western, Anglo-Saxon consumer doesn't seem to relate to black models, but does relate to mixed-race models. The term we use is 'ethnically ambiguous'. Some of my biggest earners are black and mixed-race girls. I do definitely think that there are not enough oriental, Asian girls in the industry. They're really hard to cast in the UK. In England the brief would be a black girl, a white girl or an oriental girl. Whereas, of course, if you put up a Thai girl for a Japanese campaign, the client is going to know the difference. I don't think black has got there yet and there is a huge black population which isn't being reflected in advertising.

Are clients ringing up and asking for more curvy models these days?
I did a debate about obesity and there's some really interesting statistics about this: women don't

> **Women actually like to look at something that is aspirational but still achievable. They look at that girl and think, 'gosh, she's gorgeous, I could almost be her'**

want to see a size 14 plus. The Dove ad, which used body shapes, ages and ethnicities which are traditionally sidelined, was really successful when it first came out because for the first time they showed something real, which was unusual. But what happened over time is that women actually like to look at something that is aspirational but still achievable. They look at that girl and think, 'gosh, she's gorgeous, I could almost be her, she's a better version of me'. But what they don't necessarily want to see is, 'god, is that how I look in my knickers?' – so there's quite a fine line.

What do you do at Leni's to look after your models?
At Leni's we have a workshop day of events for new models with a talk from me, not only about modelling but about how to manage yourself. We also have an accountant talk to them about how to manage their finances and a counsellor will offer her services, too.

We've had The Food Doctor speak to the girls, which was really wonderful – his focus is on learning how to 'eat' rather than how to 'diet'. We talk to the girls about fitness and yoga. A model has to be a certain size – there is a sample size and she is the prototype, so, in order to get our models to fit that we will enter a whole discussion and draw up a plan with them. Lots of models don't have that backing – there is no education. That's where we are hugely different.

What would your advice be to someone who's wanting to be a model?
Get your education first so you can always fall back on it. Also, girls that are nice and can hold a conversation are more popular – if you are in a studio all day with a model, you want to be with someone you can have a nice time with, so education is key. You don't need to start modelling before you are 18. Get your qualifications. If you are the girl being told 'your time is now, at 14', I'm just not buying it – it will

still be there at 18. If you start at 14, you'll only have one season in any case and perhaps not make much money, so forget it!

I've got two girls at the moment who are at university and successfully modelling, earning six-figure sums that will pay all their fees [in one year] and they will be left with a little 'chunk' to do what they want with it. That is a great opportunity.

Do you think it would ever be possible for magazines to have models from a range of age groups?
If one is late thirties/forties, it's impossible to live up to the level of beauty that is shown. But it is human to age! Do we all see ourselves as 15 years younger? This is supported by TV – even news presenters have all had work done on their faces, but wouldn't it be better to hear the news from someone who showed some emotion or level of empathy? This problem goes right through society. At 30 we feel on the shelf if we are not married. This is not just fashion magazines – this goes through every aspect of our culture.

What can we do to overcome ageism?
We should allow the wrinkles to show. We should also use older models. It does happen – *Good Housekeeping* and *Red* magazine are for older readers. Older women can afford the expensive fashions, so WHY are they modelled on women half their age? We need to see more realistic images – we need to see REAL women with character, warmth, interest and wisdom in their faces.

Eleni Renton has over 10 years' booking experience and has worked with such high-profile models as Naomi Campbell. When Eleni set up Leni's Model Management, her goal was to create an agency that put the health and well-being of models at the forefront of what they do.
www.lenismodels.com
Dress sizes in this article are UK sizes

Tafari Hinds

The Jamaican-born model turned musician talks about fashion that gives a F.*

What does fashion mean to you? You were very passionate and involved with Fair Trade ideals and People Tree's Emma Watson collection. We know that people are working in dreadful conditions, unable even to earn enough to eat 2,000 calories a day. We know also that tonnes of clothes end up in landfill each year.

Fashion should be fun, and it should be safe – it should be a part of life. It shouldn't be negative, but sadly all too often it is about 'consuming' and 'indulgence'. I hate indulgence, it means people are exploited under dreadful conditions, unable to earn enough money to buy the food they need to stay alive, just so they can feed our greed! This paints an appalling image of fashion, and that is why I came onboard with People Tree and the Emma Watson collaboration.

What can we do to change things?

Spread the word – get involved, find a way to make your voice heard, be passionate! I use Facebook and Twitter to make my voice heard. All my friends love fashion – it's a religion to us, it's amazing, it's glamorous, it doesn't have to be negative. After we learnt about the terrible exploitation of millions in developing countries, when we thought about the fact that they are working for people on the other side of the planet who buy things for $5 or $5,000 regardless, we decided only to wear clothes that are Fair Trade and will serve us for a long time.

I think to myself: 'What's the point of going through life and not doing anything about things?'

I will start a campaign – invent a slogan:
'Don't indulge, just be cool'
'Don't indulge, just be sexy'.
'Be you, be cool'
'I give a F* (and that's cool)' – that would be my slogan.

'I give a F* Fashion'! Perhaps we could call this book 'It's cool to care'... How about diversity on the catwalks? We need to see a truly representative catwalk, in terms of skin colour, sexual diversity, age and body shape.

This is something I've always thought about. We are all from Planet Earth – there should be no boundaries... We have moved a long way, but there is still a last taboo to overcome – the androgynous model!

What about body fascism? Models experience both physical and psychological pressure – not eating for weeks before a show, flying around the world, working into the early hours...

Yes – most of the girls don't eat for two or three weeks when it's coming up to Fashion Week. It means they can't work, study or function properly at all. They need to know that Erin O'Connor has a Model Sanctuary and she will defend a model. An agency or a client can get into serious trouble if shown to be putting models through this kind of stress.

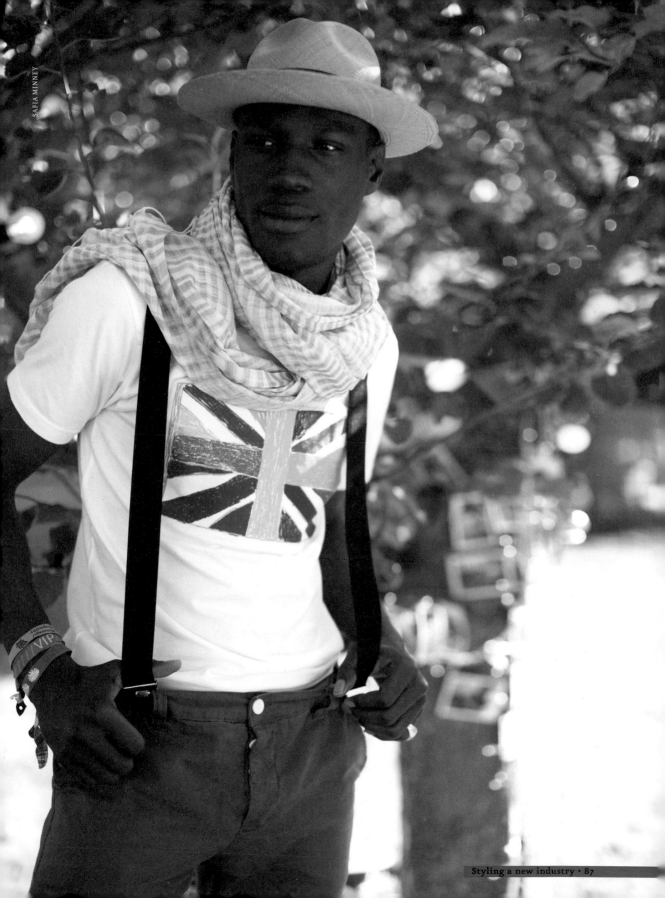

What do guys do to make themselves skinny or super-muscular? It's not just good, old-fashioned working out, is it?

Guys will go to extremes to keep their body perfect, otherwise next season you might not be used. Drugs come with that, to keep yourself fit. It shouldn't be like this – you should take a stand by saying 'NO' and educate your friends.

If your Mum or Dad had known, they would have been so upset – you so want your child to be healthy and to be happy with who they are.

Yes – they wouldn't have let me model ever again! There is lots more... Like women, guys get implants built into their abdominals, or they break their jawbone for a more chiselled profile. It all happens – it's another form of plastic surgery.

What should models be like?

Models should look NATURALLY beautiful, slim and healthy, not thin and ill. They would be energetic, it would be fun, it would be sexy. It would be hot!

Designers and advertisers HAVE to change things, they have the responsibility. Girls are starting as young as 14 years old now. By 20 they are out of the business and depressed. We need to see older women. Yes, they might be a bit bigger, but they look healthy, sexy and happy in their skin. The luxury brands should take the lead, then it will come down the high street – they have the power to trigger a change.

It is ironic that it is the older women who have the buying power.

Yes – but we are fed the ideal of youthful looks. Until we are happy just to show older models, who are just beautiful people, nothing will change.

Look at M&S [British retail chain Marks & Spencer] ads for the past five years – they had a variety of women in their campaigns. One of them looked like she could be the mother of them all! She looked lovely. That was encouraging and reassuring. I know Twiggy is a famous model, but she's just a real person after all.

Tell us a bit about the people who have shaped your thinking.

In fashion modelling and fashion media we have the power and influence to break down cultural barriers. We can create a new cool. Think of Grace Jones. She didn't have long blond hair, she had a bald head and was scary-looking – she was a pioneer! Now we have models like Andrej Pejic, who has caused a huge gender debate, designers like Vivienne Westwood, photographers and stylists like Simon Foxton and Nick Knight, journalists like Edward Enninful, once editor of i-D. Simon and Nick were totally innovative and influential – they broke with the norm and used black and Asian models long before anyone else dared to. They were both skinheads, which represented a rebellion against oppression. They brought that energy into fashion; they weren't sticking to the politics of what they should do – they went beyond that. These men had the ability and changed things – I like that a lot.

We can build a new cool. It is possible. It will come. We are bursting for that. People do realize that we have indulged too much – they do care. We are ready for this change. A friend of mine in Jamaica is making fantastic handmade hats in his bedroom – his work is all about cultural integrity. When people see those images, they think, 'wow, that looks so cool', and things change for the better.

Hat producer Karl Brown – www.khalilshatitude.com
www.myspace.com/tafarihinds
Tafari is represented by FM Model Agency

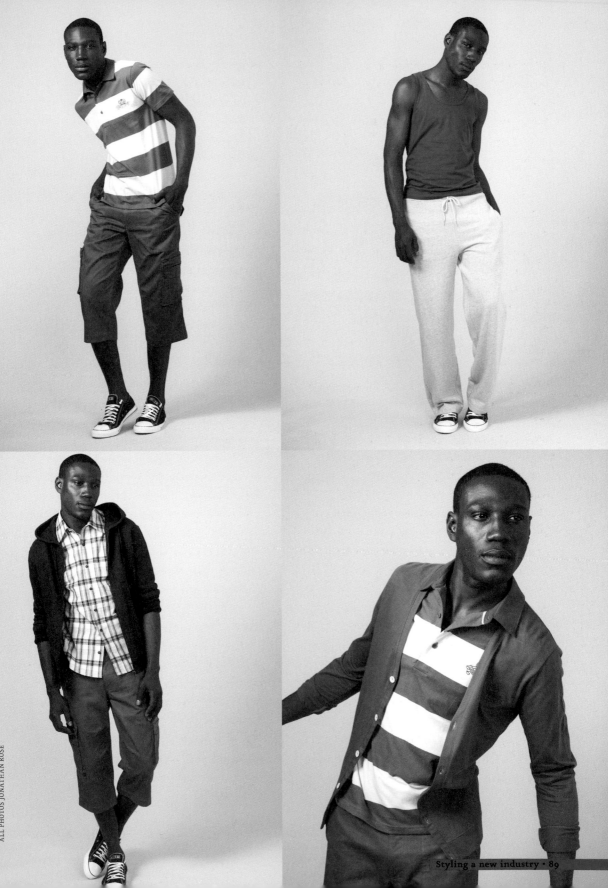

Gemma Rose Breger

Fashion stylist

How did you become a stylist?

I studied Fashion Communications at university, then became a stylist for Topshop in London before deciding to go freelance. I absolutely love my job. Each day is different, as is each client, photo-shoot, look book and location.

What are the differences between styling for a catalogue shoot, an editorial shoot or a celebrity?

If I am shooting for a People Tree catalogue, I will usually go in for a prep day to check all the clothes, to plan the outfits, and to see if we will need anything extra on the day. I usually take quick photos of each look so we are fully prepared. I love working for People Tree; their ethos gives me so much satisfaction.

Styling for an editorial shoot takes a few days of prep. Once I receive the brief, I go around the stores borrowing clothes. I plan each outfit meticulously, as I need to be fully confident with the outfits, and have extra options in case something doesn't look right on set. I am super-organized as all the clothes are my responsibility, so I have to make sure nothing gets lost, broken or that the model doesn't spill her lunch down the clothes! Later, I have to return all the clothes to the stores (although I do occasionally fall in love with a dress on a shoot and end up buying it for myself!)

When I style a celebrity, I have a consultation with them before I start to select the outfits. Unlike working with models, the celebrity has more say in what she is wearing. If she is not happy in the outfit, it will come across in the image.

Do you think the fashion industry is changing and becoming more sustainable?

Things are gradually happening. At least people are having conversations about Fair Trade – the word is out. I remember when you were not even allowed to mention that a model looked too skinny; now it makes international headlines. Vintage is such a huge trend, and it is very much 'in-fashion' to be wearing something that has been worn before.

Sadly, some of the big brands are ignorant. I once worked for a big UK high street store and they don't even recycle... think of all that packaging!

Sustainability is a hot topic. Big names should start publically speaking out in support of sustainability, but 'saying it' is one thing, 'doing' is another. Why not introduce a certified accreditation that big brands and designers can apply for to prove that they are doing their bit? That way, customers will know who operates sustainably and can pledge their allegiance.

How eco are you in your life and work?

I try to do my bit all the time. I recycle what I can and on a photo shoot, I unplug everything – even other people's chargers!

When I style I try to use vintage and I never use real fur. I love working with ethical brands like People Tree; it is so satisfying. They make people think about how each of us can make the world a better place.

www.gemmarose.co.uk
Gemma is represented by Carol Hayes Management

Gail Rhodes

Make-up artist

I trained at The Glauca Rossi School of make-up. After leaving, I assisted Mel Arter and Sharon Dowsett, both power-houses in the make-up world. That was when the training really began, watching and learning from artists at the top of their game. I put together a portfolio of 'tests' – a bunch of creatives come together with an idea, model, stylist, hairdresser, photographer, and shoot some pictures. This is a great way to build a portfolio which you can show to potential clients. It took a couple of years as an apprentice before I started to get regular work.

It is the Art Direction that varies. On a commercial/catalogue shoot you are pretty much bound by the look that the company wants to project – I am usually asked to make the girls look healthy, beautiful and natural.

An editorial shoot often allows much more freedom. The stylist will give the story brief for the make-up artist and hairdresser to interpret. I always aim to complement the hair and the styling, not detract from it.

Working with celebrities, you are generally guided by the celebrity and their management. They have a very strong idea of the image they want to project.

It is getting much easier to source ethical and organic products in skincare and beauty products. I love Dr Hauschka rose day cream: I'm never nervous about one of my models reacting to it. Also, a must-have in my kit is Neal's Yard Frankincense facial mist – everybody loves it. As far as make-up goes, I love 'Organic Glam' – the make-up range from The Organic Pharmacy' – and Aveda's Smooth infuser style prep.

I would like to see tougher government guidelines on what is sold in our country. The huge fashion brands who are stocking garments made in developing countries in appalling conditions should be held accountable.

When I travelled with People Tree for a catalogue photoshoot to Bangladesh, I saw first hand the problems and solutions.

It was life-changing. I was deeply affected by the poverty I saw in the capital, Dhaka… I saw whole families living under tarpaulin, three and four generations. It shook me to the core. The contrast with the comfort we take for granted in our lives is staggering.

Then I travelled to see People Tree's producers in rural Bangaldesh – it is a magical, incredible place. The freedom and the happiness of the children running around the village, the openness and welcoming nature of everyone there, was overwhelming. To see the men and women at work, in good working conditions, hand-producing beautiful clothing, was absolutely inspiring.

I would never condone the use of retouching to change a person's features, smooth out wrinkles or alter body-shape; I feel we should celebrate all body types and features. However, if a model turns up for a shoot with a really bad skin break-out (and, believe me, it happens) then retouching can be the make-up artist and photographer's best friend!

We are losing our obsession with painfully thin girls; models now look much healthier, and agencies are more aware of their responsibilities towards the young people they employ. My advice for everyday beauty is not rocket science: sleep, water, little or no alcohol, absolutely no cigarettes, and exercise. I'm working on it!

Gail is represented by Artistic License Agency

Redman and Rose

Photography and creative duo Andie Redman and Jonathan Rose collaborated with People Tree for the Forest and Fauna photoshoot on the following pages. Andie Redman explains how they work together.

JONATHAN ROSE

My first memories are of being in a photography studio. My father was an interiors advertising photographer, and my Mum was a stylist, so it's in my blood. I've always known that's what I wanted to do, obsessively reading *Vogue* from cover to cover from an early age and making my own clothes. After a stint at art college, I decided that I would learn more through experience and assisting work than through an expensive degree, so I moved to London, where I assisted fashion and interior stylists and photographers on various magazines including *The Face*, *I-d* and the *Sunday Times*. I learn best from being very hands on. Jon is the same; we both went straight into photography learning on the job and building confidence through experience. Jon has worked with some of the world's greatest photographers, learning incredible techniques that he adapts to our work.

We have a deep understanding of and respect for each other's creativity and have often worked together over the years. Two heads are better than one. We are both strong personalities with big ideas that we want to turn into reality. Jon's talent is more technical, whereas mine is more creative, though every aspect of our work is discussed together. There are many photographic duos working these days, most famously Mert and Marcus – it's a very exciting movement. There is no competition between us to take the best shot; we never take credit for who took the frame used, just swap the camera over to gain different perspectives and expressions of the shot in front of us. The actual shooting is just a tiny fraction of what needs to be done in pre- and post-production.

As individuals, we have quite contrasting tastes. Jon likes ordered, clean lines, simplicity and studio work, whereas I prefer chaos, the bizarre, and being outdoors on location. As you see from the shoot, we pull our polar opposites

together to create our style. This is constantly developing, but that is a key factor in carving a niche in fashion. This is a recent venture and very exciting for us.

We have been very lucky as our jobs have taken us to the corners of the planet and we have met some extraordinary people. But the reality is that the days are long, physically exhausting and require total concentration.

We spent days preparing for the People Tree shoot, which was great fun, as we were given the latest autumn/winter collection and given free rein to go wild. It was particularly rewarding to work with a company whose ethics we really believe in. We wanted a highly stylized theme, incorporating vintage, custom-made pieces by Clea and myself, and clothes from Junky Styling and Absolute Vintage. Everything had

to be eco-conscious and evocative of the power of Mother Earth. We didn't want the shoot to look too predictable; we wanted to do something imaginative with a bold twist. The women are like little splashes of colour; I love the sumptuousness and richness of what they wear against the stark background of the wintery forest. The light gives the shoot a magical, ethereal feel.

I'm a very feminine woman, but I think femininity has been lost on the catwalk – it's very androgynous. Designers are trying to be too clever and have lost the natural shape of the body. Women have a nurturing role and these attributes and values are very much needed. We've trashed our environment and we need to learn to respect it again.

www.redmanrose.com

Clea Broad

Designer and maker of bespoke costume and fashion accessories for photo shoots and other creative projects.

I started off studying sculpture, then moved into costume design and cutting-edge floristry. My craft is an amalgam of these disciplines, while my artistic influences are increasingly found in nature. Styling for this People Tree shoot was a great opportunity for me to showcase the richness of Fair Trade fashion, mixed with vintage and charity-shop fabrics and sculptural finds from the forest floor.

My studio is my haven and possibly where I feel most myself. Finished pieces and works in progress hang from the walls. I like the feeling of being a collector and a curator. I have shelves bursting with jars full of curiosities: crystals, beads, dried petals, circuit boards. There's very little I won't stop to collect – you never know

what project is around the corner.

I took the People Tree Autumn/Winter collection and layered pieces with vintage finds. I wanted to make accessories to create fantasy and drama. A bunch of ornamental willow became a fantastical head-dress weaved with antique ribbon to create the illusion of fluid antlers. I made a paper collar by curling and sticking multi-coloured recycled paper to tie in with the colourful embroidery on a black People Tree dress. It was a really great shoot to style. Seeing the outfits on the models, with Hamilton's fantastic hair and make-up, in the wonderful setting of the forest, really is like seeing a dream come to life.

www.cleacreative.com

Forest and Fauna

Styling with Fair Trade, vintage and pieces from the forest floor.

Photography: Redman and Rose
Styling: Andie Redman and Clea Broad
Hair and Makeup: Hamilton Stansfield
at SLR management
Photography assistant: Christian Bragg
Retouching: info@packhound.com
Models: Julia B, Elin and Vita @ Leni's

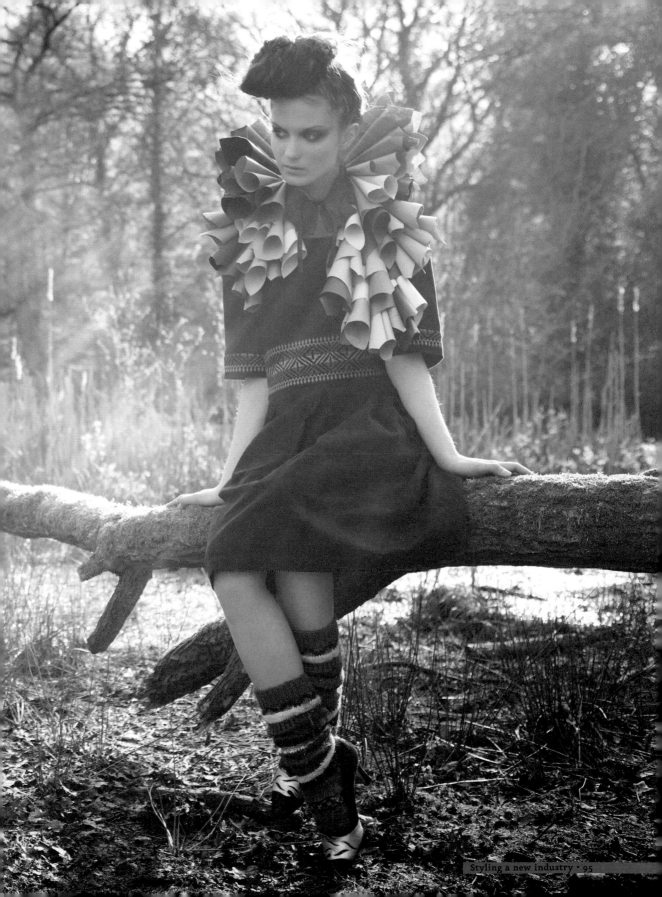

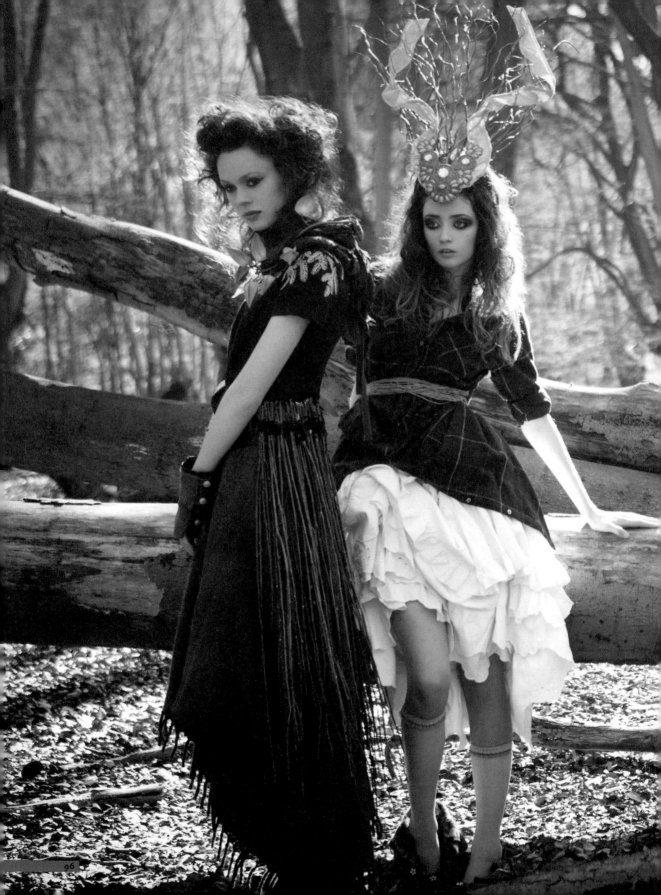

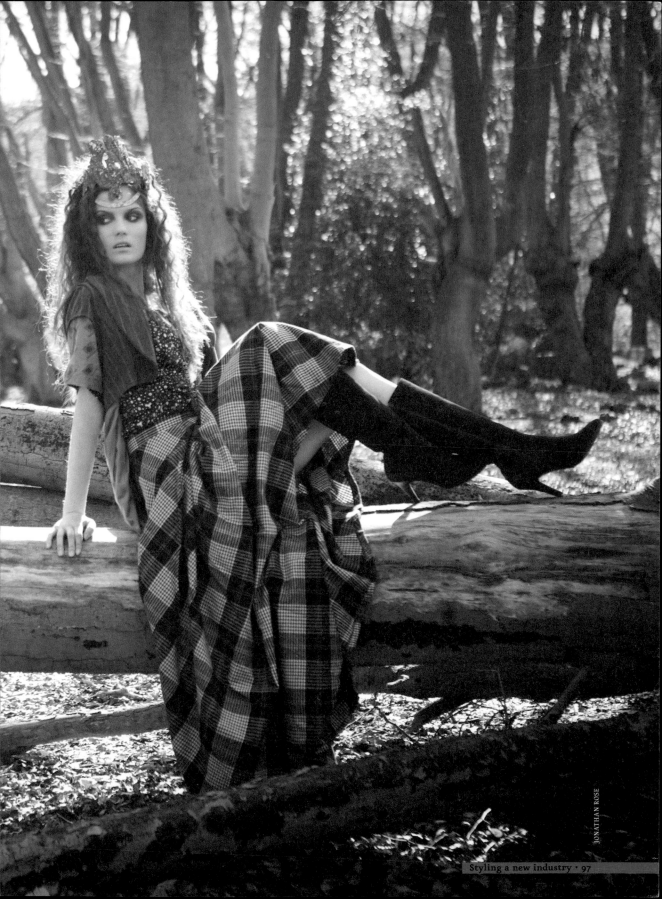

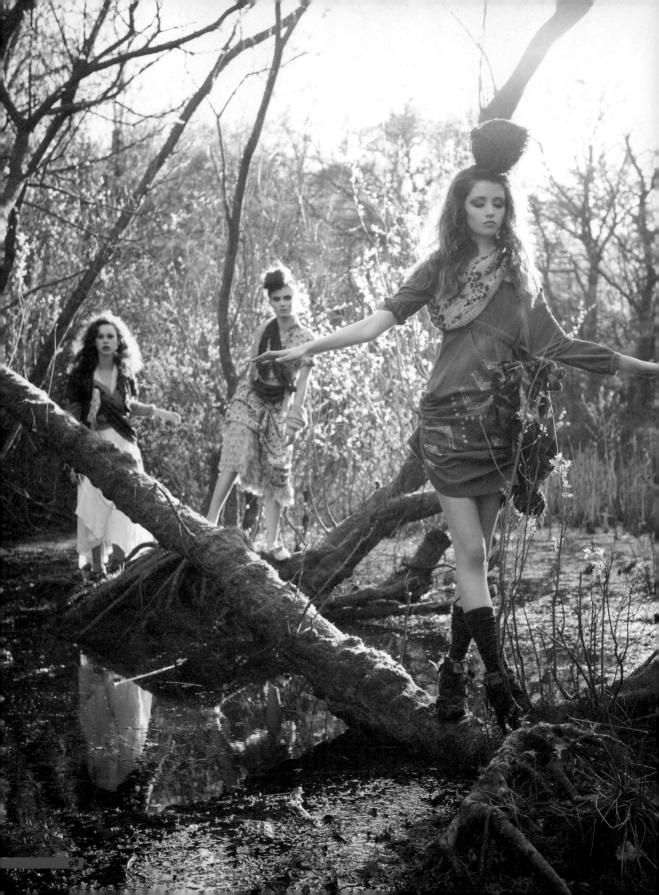

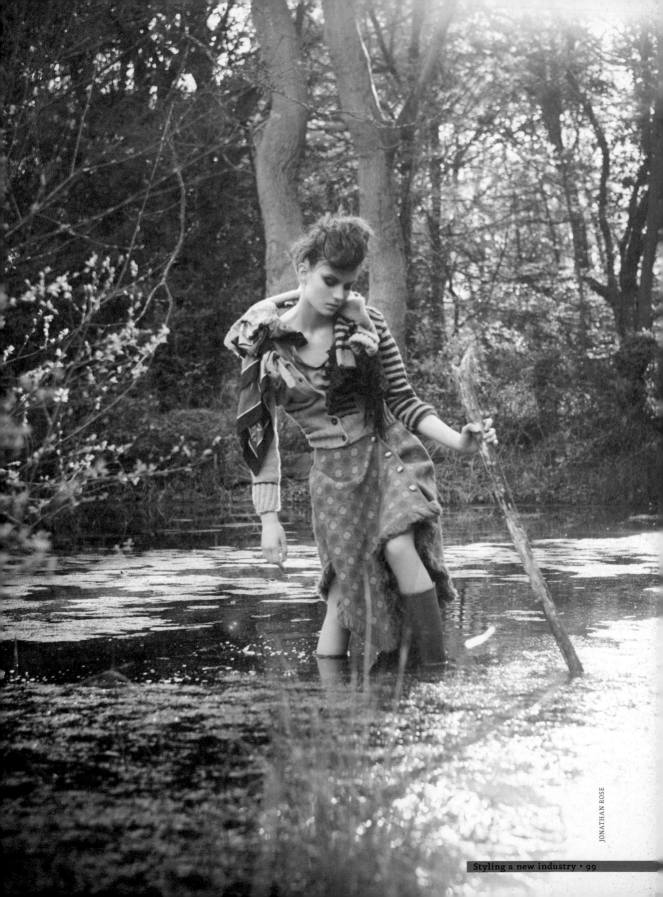

JONATHAN ROSE

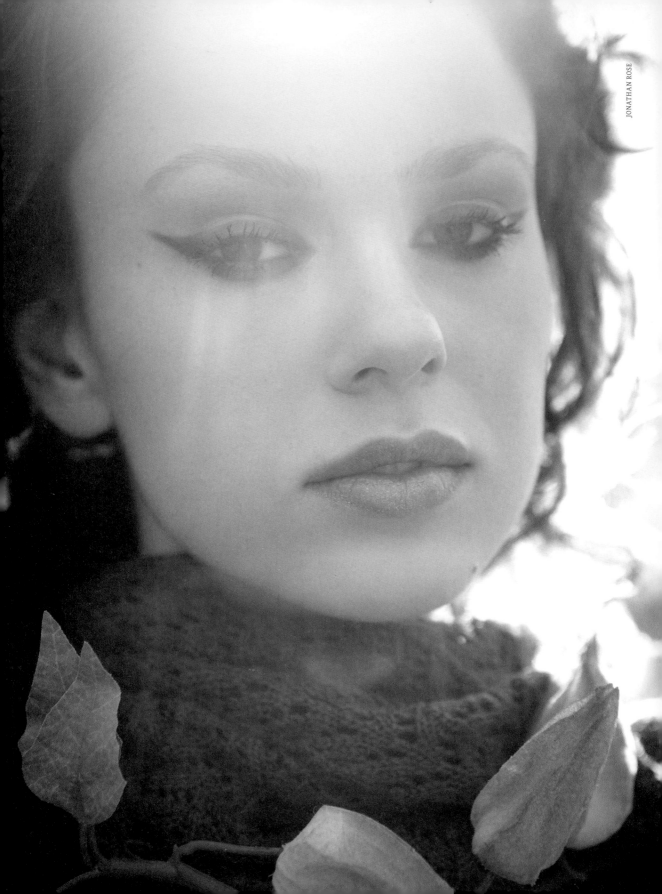

Designing a new industry

Handscreen printing at Eastern
Screen Printers, Saidpur, Bangladesh.

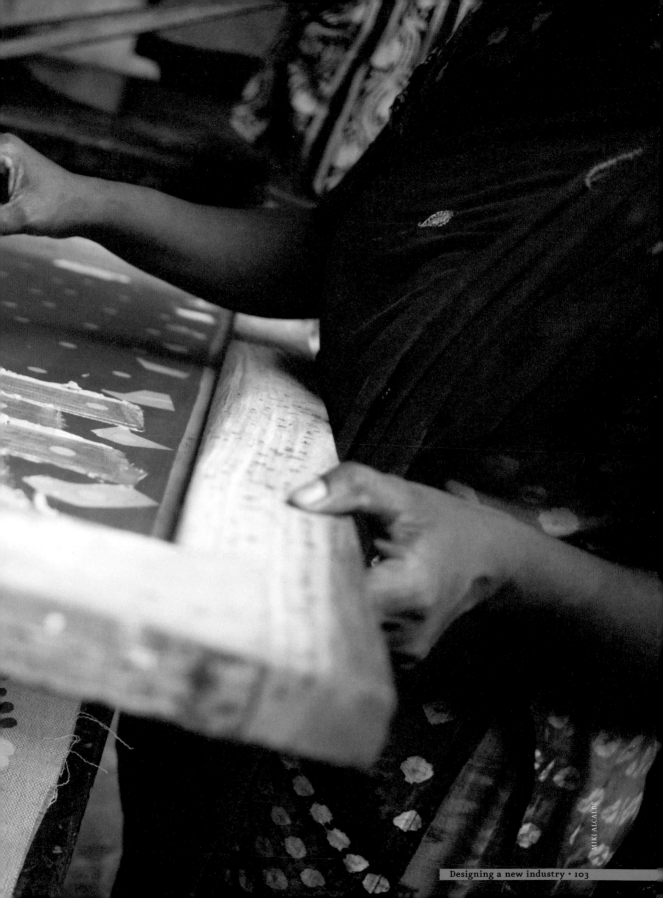

Vivienne Westwood

Safia Minney meets Vivienne Westwood and finds someone equally passionate about saving the planet.

CHRISTAIN SHAMBANAIT

What is the antidote to fast fashion? What does the future of fashion look like?

Buy less, choose well and make it last. Someone said that fashion is aspirational and only rich women can afford it; but people have never looked more poor and awful. People don't wear fashion, it's called GAP and I think it's like a gap between their ears [laughs]. Fashion is here to help to make people look great. But today, a lot of what you see in stores looks bad – those mini dresses with a high waist and spaghetti straps in synthetic, worn with black leggings, don't help people look good. Imagine how Nigella Lawson would look in that and how gorgeous she looks in a beautifully made hourglass-shape dress. Even Kate Middleton wants to be an ordinary woman, to wear what's on the high street. Women should want to look extraordinary, that's my fashion philosophy.

What is an extraordinary woman?

An extraordinary woman doesn't have to buy high fashion, but if she does she can take into account that the people working to produce it are well paid. The main fashion lines are subsidized by spin-offs such as perfume, tights. The garments produced are usually sold at cost. It's a model of Get a Life – fashion is here to help. If you love something, wear it all the time, don't just suck it all up and consume. Find things that suit you. That's how you look extraordinary.

...And the future of humankind?

Climate change is such a serious issue, it's going to change how everyone lives. Governments need to do more. I've just written a letter to China to ask them to show the way (www.activeresistance.co.uk). I think countries like China should take leadership. Businesses are just continuing to make profits, despite the crisis. There are thousands of charities, NGOs and networks working for change and raising awareness. We need to link this all together, get people behind it, so we won't crash into this... uninhabitable, hot planet. [Gesturing at a map showing a third of the land marked in red.] This is how much of the world will be uninhabitable if the world's temperature increases by five degrees.

Why do you think using hand skills is important?

The whole idea of machinery is that people have more time for leisure and culture, and yet that isn't at all what's happened. The opposite has happened – the rich get richer and the poor get poorer. It's a very nice social atmosphere when people sit and work together. It's so fascinating that making clothing through Fair Trade can do this, too, as you more often hear of Fair Trade bananas.

www.viviennewestwood.co.uk

Vivienne Westwood mini dress made by People Tree for Marie Claire eco issues, published in 30 countries to raise funds for a Bangladeshi charity.

ADAM BROWN

Orla Kiely

The Irish designer talks about her passion for textiles and her enthusiasm for Fair Trade fashion.

Why did you want to become a fashion designer, and what got you started?
Well, I think it must have all started when I was given a sewing machine as a little girl! I loved to sew and would select fabrics to make clothes for myself and my younger sisters. Also, from an early age, I have always enjoyed art;

specifically graphic, bold shapes and colours. Being brought up in Ireland in the Sixties and Seventies had a strong influence on my career path. While studying at the National College of Art and Design in Dublin I was opened up to new worlds and possibilities, but I knew by the end that I wanted to focus on textiles. My career has naturally progressed through textiles fashion, homeware and even a fragrance!

Your prints are now world famous – what inspires them?
As a designer I find I never stop absorbing ideas from the world around me – even if I am not conscious of it! Both living in London and travelling for work allows me to see so much. Inspiration from print can come from anything as small as everyday household objects to a painting or film. I love to visit exhibitions. I also take inspiration from vintage fabrics and love trawling through markets and vintage stores.

Why do you love natural textiles?
I find that natural textiles have a wonderful texture and often have so many interesting little imperfections that make the fabric unique. Our natural

MIKI ALCALDE

Action Bag, a Fair Trade group in Saidpur, Bangladesh employs 150 women.

Eastern Screen Printers in Bangladesh employs 30 women.

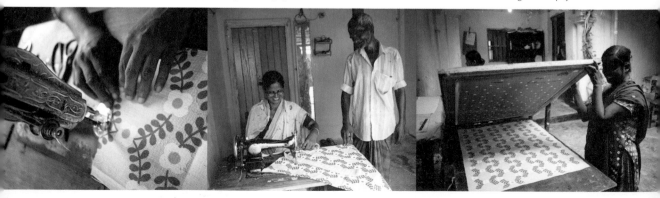

vegetable leathers age beautifully. Over time, the leathers soften and the colours develop a rich hue which makes your bag personal and interesting.

Why did you want to support Fair Trade groups?
Within the fashion industry it is so important to know our products come from a sustainable and socially responsible source. All designers need to be responsible for where and how their products are made.

What did you think when you saw photos of your bags being made?
It was fascinating seeing this hands-on and traditional approach to the manufacturing process. As a designer, it's important to me to see how my products are being made, and to build a close relationship with all my team. This has certainly been achieved with this project.

Is the functional aspect of product design as important as the visual design?
Functionality is essential for all my products. I want things to be aesthetically pleasing but also practical. We design with our customer in mind.

In which ways do you have a 'green' lifestyle? Are you an ethical customer too?
I try to be as responsible as I can in both my personal and design life. I walk to work every day with my Labradoodle Olive, which is a great form of exercise, too! I try not to fly far and mainly holiday in Ireland, crossing over on a ferry. In everyday life I try to use locally sourced products with reduced packaging. Within my work, I endeavour to offer my products with reusable packaging. All our bed linen comes in a beautiful printed box which, having its own functionality as a storage box, can be used again and again.

www.orlakiely.com

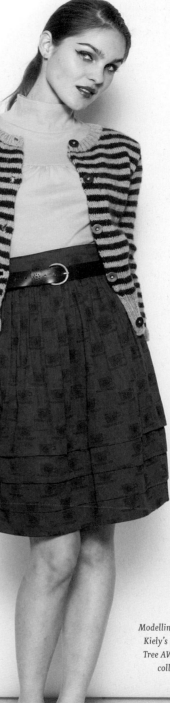

Modelling Orla Kiely's People Tree AW11-12 collection

JONATHAN ROSE

Mihara Yasuhiro

The Japanese designer explains why 'craftsmanship' and the natural world are central to what he does.

You use a lot of organic cotton in your collections.
Yes, we've been using it for a while now. We used to select fabrics based on image alone and rarely paid attention to where or how they were produced. Now we're more aware of the huge amounts of agricultural chemicals used in conventional cotton cultivation; also, organic cotton is better quality compared to conventional cotton. Organic cotton is stronger and it's more comfortable to wear for the body and mind. It is good for human beings as well as for the planet.

Why do you think Fair Trade fashion is important?
To keep costs to a minimum, the conventional fashion industry produces clothes in factories where the costs of fabrics and labour are low. They are always trying to find the cheapest deal.

For example, a major production area for ordinary shoes used to be Korea, then it moved to China, and now it's in Vietnam where wages are rock bottom. This raises many issues. We need to question the ethics of using cheap labour and realize that repeatedly shifting production forces an unstable economic situation on millions of workers.

I want to design and manufacture leather shoes in Japan because I hate to lose our Japanese craftspeople. I want them to be part of my life. Countries abroad also have many craftspeople with a variety of skills. I'm interested in original traditional skills like embroideries or

dye techniques in India. I hope one day to visit Fair Trade groups with People Tree and design something right there.

Are you happy with your Fair Trade collection?
Each collection is a new discovery. Working to the high standards and values of Fair Trade makes me feel eager to create 'other' designs. The hand skills of Fair Trade artisans have great potential. I have a lot of respect for the culture and craftsmanship of these artisans and love how they appeal to customers. Working under Fair Trade conditions gives me a great sense of accomplishment – as a designer I can bring a smile to the face of the artisan and the customer.

Where do you think the fashion industry is heading?
Fashion has developed into a huge industry, with many inherent, serious problems which we have not addressed properly. In the same way that oil and other natural resources have caused conflict, fashion may also cause conflict. How can we say we really enjoy fashion under these circumstances? We urgently need to reinvent the industry.

www.miharayasuhiro.jp

Safia and Yasuhiro hanging out.

Tsumori Chisato

Japanese fashion designer, famous for her bohemian prints and style, explains why she collaborated with People Tree.

I had visited People Tree shops and loved their handcrafted items before I was asked to do a collaboration with them. I thought it would be fun to create something together. Through this collaboration, I hoped to raise general awareness of Fair Trade and contribute to improving the lives of people in developing countries.

As I know the design process, I thought of People Tree's easy-to-wear, relaxed atmosphere. Also, I wanted to bring out the atmosphere and the texture of natural fabrics using appliqués and hand embroidery. Knowing the differences between Fair Trade and my conventional processes and production time made me realize what challenges making handmade clothing involves. The samples were very well made so I didn't make many alterations. I'm happy that we've made a very *kawaii* [cute] collection together.

Chisato's collection appeared in People Tree's SS09 Japan catalogue.

www.tsumorichisato.com

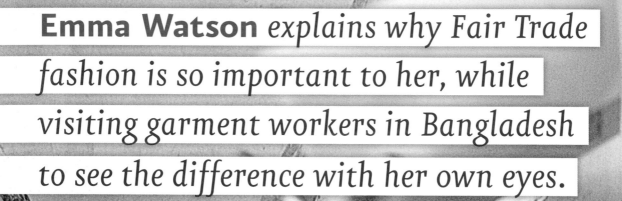

Emma Watson explains why Fair Trade fashion is so important to her, while visiting garment workers in Bangladesh to see the difference with her own eyes.

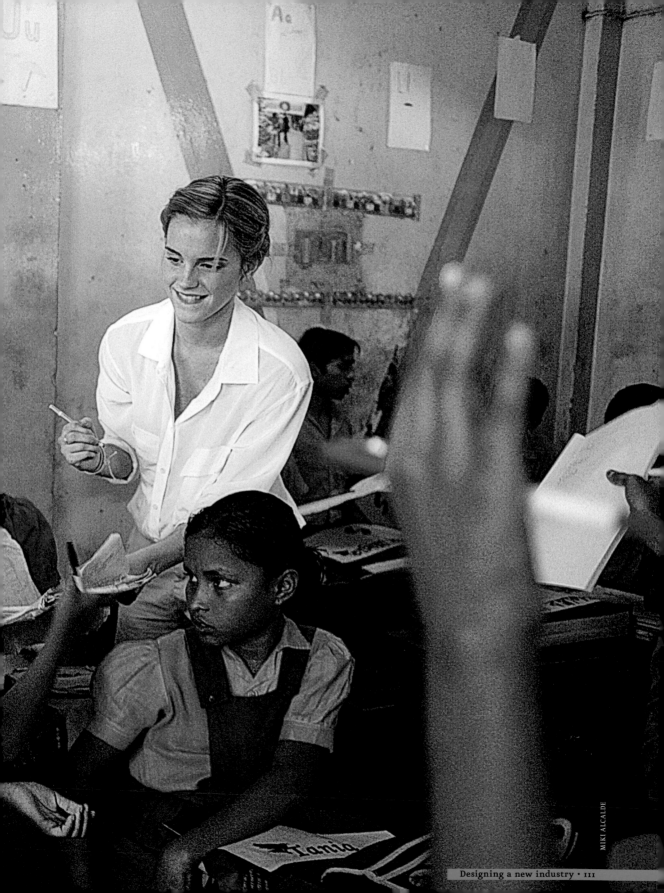

MIKI ALCALDE

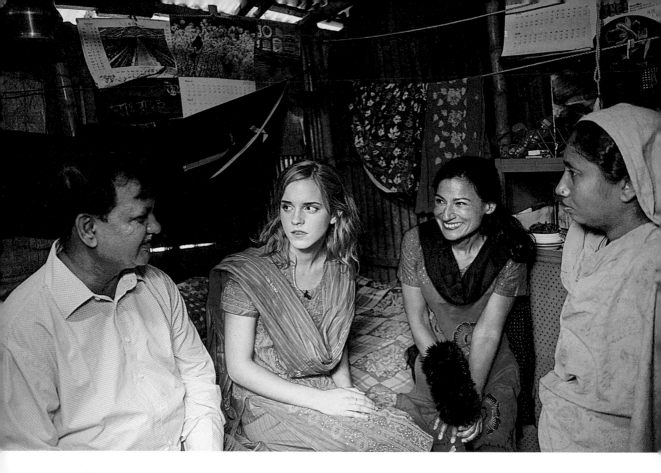

Safia Minney interviews actor Emma Watson as they visit the women at Swallows, one of People Tree's Fair Trade partners in Bangladesh.

While filming *Harry Potter* and studying, how did you find the time to design a Fair Trade youth range and promote Fair Trade fashion?
I didn't want to wear something on my body that hurts the environment or the people in it. It's hard to know what is good and what is bad on the high street and equally hard to find fashionable or youthful ethical clothing. So, I decided to work with People Tree to put together a collection I could be proud of in terms of both ethics and design.

I often worked late at night, fitting in meetings between filming *Harry Potter 7*. In between takes I sketched and painted. Inspiration came from all sorts of places,

whether I was brainstorming slogans with Tafari (my friend and appointed menswear advisor) or rummaging through my flatmate Sophie's wardrobe. I couldn't have done it without the enthusiasm of the peers around me: teenagers who love fashion but want to wear clothes that help the world's poorest people – not make them poorer. It shocks me that even today less than one per cent of cotton produced in the world is Fair Trade and organic.

Why did you want to visit Fair Trade groups yourself?
Following my summer collection for People Tree, I wanted to visit Bangladesh to see the difference Fair Trade makes. The contrast

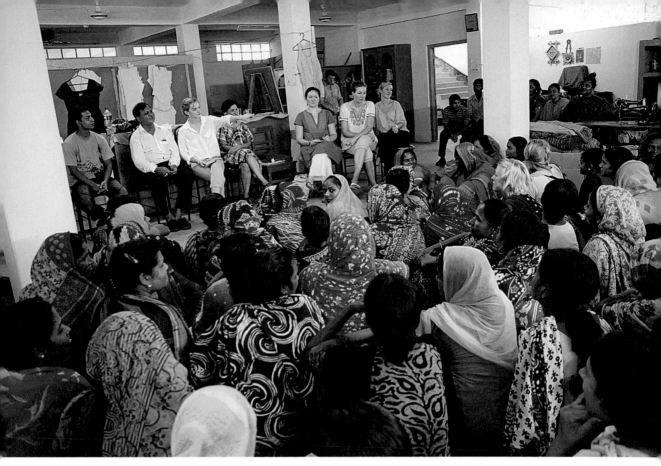

Left: Emma interviews garment workers in their homes; Above: Emma meets the Fair Trade group making her collection.

between the slums in Dhaka [Bangladesh's capital], where the people who work in the garment factories live, and Swallows [People Tree's partner organization] was all too apparent. Even so, I still find it hard to convey how much Fair Trade means to those producing our fashion – it's just so impressive to see how the women have used Fair Trade to escape poverty and empower themselves and their children. I was very moved and inspired.

It's just so impressive to see how the women have used making Fair Trade clothes to escape poverty and empower themselves and their children

Tell us more about Bangladesh and about meeting garment workers in their homes.

I wasn't sure what to expect when we arrived in Dhaka. I was expecting it to be very busy and hot but the first things that really struck me were the noise and the traffic! Soon after arriving, we visited the slums where the garment factory workers live. Again, I had some preconceived ideas, but nothing prepared me for the reality. It was upsetting to see the conditions in which these people live, but I was incredibly moved by their

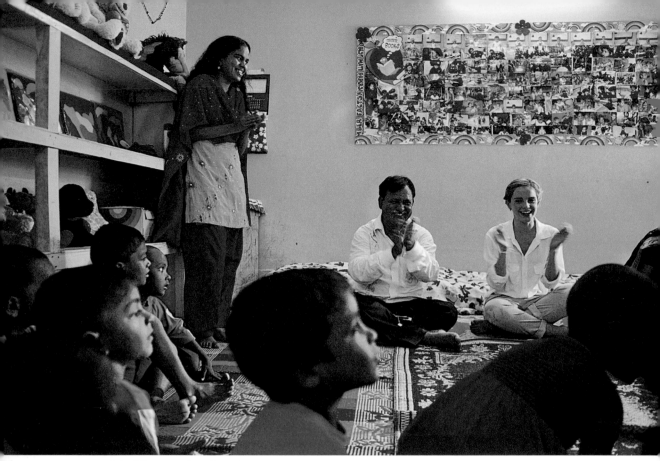

Emma sits with the children at Swallows daycare centre.

spirit and friendliness in spite of such apparent adversity.

Bangladeshi garment factory workers have been protesting for a living wage because their living conditions in the slums are appalling. Can you describe what facilities people have there?

Facilities? There are no facilities to speak of. In the building we visited, I saw one shower, one cleaning place and one hole in the floor which was the toilet. This was for a whole floor. That floor had maybe eight or nine rooms coming off it, and each room housed a whole family. Even if you estimate that there were only four people in each family, that is 32 people to one toilet.

Even though the cost of living is much less in Bangladesh than in the UK, they seem to work around the clock and still do not have enough money to buy food to feed their family, or live any kind of life at all. I really do hope that they achieve their goal of £18 [$29] a week. If they can, it would be life-changing for them.

Having seen the slums in Dhaka and the conditions in which these people live and work to produce 'fast fashion', I would say that this is not the way we should be making clothes in the modern world

You then went on to meet Amin Amirul, president of the National Garment Workers Federation...

It was an honour to meet Amin. Seeing his office and what he does with so little, I felt like it was

him against the world. What he tries to achieve just seems so enormous. He is so determined and he is not going to give up until the lives of the garment factory workers have been improved. He was a very compelling speaker.

You also visited the women's project Swallows to see the difference Fair Trade makes. At Swallows clothes are made completely by hand so as to employ as many women as possible and build a healthy community. What was it like seeing all those different processes of making clothes by hand?
I always find it difficult to impress on people what 'handmade' really means. To make a simple garment they have to produce the yarn, hand-dye the yarn, get it onto the loom, then weave the fabric, cut it to the pattern, sew it into the garment and then embroider it – all by hand. It is so hard for people to imagine what it takes to create something and how special that item of clothing is.

What would you say to people who say 'we're in the 21st century, so why make it by hand – why not make it by machine?'

Having seen the slums in Dhaka and the conditions in which these people live and work to produce 'fast fashion', I would say to those people that this is not the way we should be making clothes in the modern world. These workers have no rights and work every hour of the day just to feed their families. Hand production creates jobs in the rural areas and gives families the option to stay together, rather than one or both parents having to move to cities, and they are paid a fair wage. It empowers people and doesn't take away their dignity.

Can you imagine yourself as a Bangladeshi working in a garment factory?
I cannot imagine how I would have the mental ability and strength to go into the garment factories in the slums every day and have my children living 600 miles away. We interviewed a woman in the slum in Dhaka. She was very candid about the fact that there just wasn't any hope for her. There is no hope for anyone living in those conditions and being paid that kind of wage. Coming to Swallows, I see that

Emma learns how to handweave fabric for one of her designs.

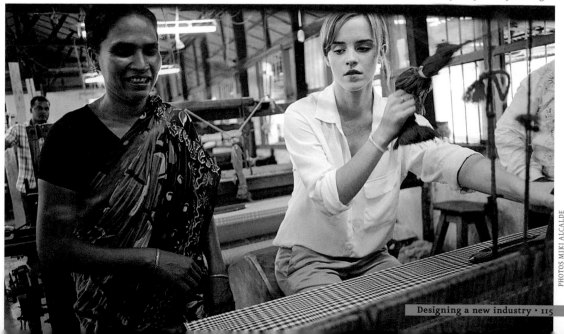

there is an alternative. The living conditions are modest but it's clean and there is a real sense of community; their families are together and they seem to love and be proud of what they are doing – many things that we in the West take for granted. Swallows is special and I need to believe for my own peace of mind that there will be more places like this in developing countries.

What kind of message do you want to give to people your age after what you have seen?

I don't know how to impress upon people the importance of Fair Trade. It is so hard to get people to care and to realize what a huge difference Fair Trade can make to someone's life. If, when buying an item, whatever it may be, people have the choice to buy Fair Trade or non-Fair Trade, they should buy the Fair Trade item. It really does make all the difference – the contrast between Swallows and the slums in Dhaka is testimony to that.

People can be so trend-orientated – after two or three months there'll be something new and they'll dispose of what they had before. But I think people should value what they own. If

they buy something from a Fair Trade producer they know that it's come from a really special place – that it's been made with love, care and pride and can be kept forever.

Swallows has a daycare centre for 60 children between the ages of three months and five years and a school for 300 – not just for the workers' children but also those from the wider community. How does this help?

Even low-income children get access to good-quality education and a good start to life. Not only do these women have jobs, but they're earning the same amount as men – there is gender equality, they are empowered. They're able to support and look after themselves, and live in dignity.

I think if you do care about the developing world then Fair Trade is even better than giving to charity, as you're essentially giving these people the opportunity to help themselves out of poverty – and that's all they really want.

I really believe in Fair Trade and I just want to see more of it in the world.

Emma checks the images for her catalogue.

Front cover image of Emma's first collection with People Tree.

SAFIA MINNEY

ANDREA CARTER-BOWMAN AT A AND R PHOTOGRAPHIC

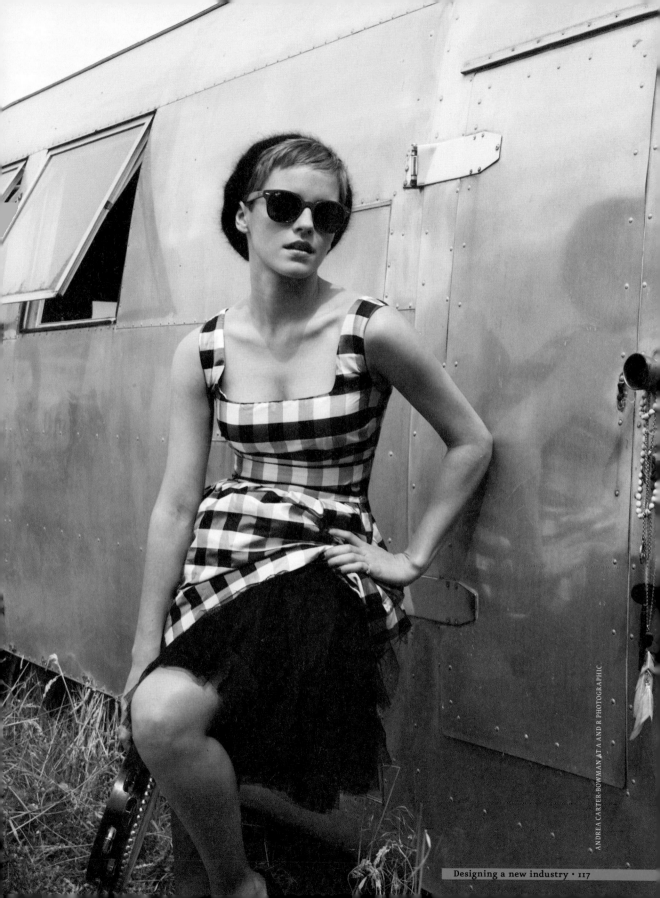

Bora Aksu

The Turkish-born fashion designer sees the world waking up to truth, beauty and the need for sustainability.

How did you start your career in fashion?

I started drawing when I was very young. My drawings were not exactly like other children's – nature, houses, fairies and mountains, etc. I drew the people around me instead, and as I was growing up in the Seventies, everything reflected Seventies fashion.

In 1996 I went into Central St Martins [College of Art and Design, in London]. I just went in with a portfolio of drawings because I didn't have anything else and they gave me a chance. I didn't come from a fashion background and I didn't understand anything about fashion. It took me a long time to understand how fashion works.

What would you recommend to people wanting to study fashion design?

First you need to ask yourself why you want to be a fashion designer. Is the answer: because you really love it, have a passion for it and don't see it as a 9-to-5 job? Do you want to give your life to it? You can do it without going to college, but I can't deny the advantages I got from the graduation show at St Martins. Through that platform I got my first sponsorship and press support.

The most important thing is to decide what route you want to take. You can become an intern with a designer and learn that way. Nicolas Ghesquiere, now Balenciaga's designer, did an internship with Gautier at the age of 16.

There is no formula, everyone should find their own path to fulfil their passion.

Why do so many young people want to become fashion designers these days?

I would like to say it's creativity blossoming, that we want to express ourselves. Unfortunately I think it's also because it's seen as the key to fame and wealth.

A lot of interns want to arrive at the finishing point without putting in the hard graft involved in understanding the process.

What's really important is to be interested in the 'kitchen' side of fashion – how to actually make clothes. I see it almost like a restaurant – you have the kitchen and then you have the whole ambience where people dine, but that is not where it is really happening. The talent and the chef are in the kitchen. Fashion shows are the restaurant – you go there and taste the whole ambience but you don't know who has done what, how many hours have been spent making the collection.

How would you define your fashion design identity?

It is definitely romantic and feminine but with a dark edge. I like roses but I like them in black. I take inspiration from a ballerina and then I mix it with Gothic influence like Edward Scissorhands – a pinch of this and a pinch of that. It's not that easy. I have to try it and see

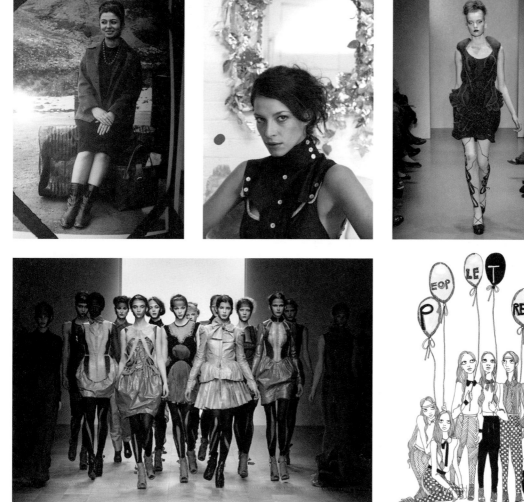

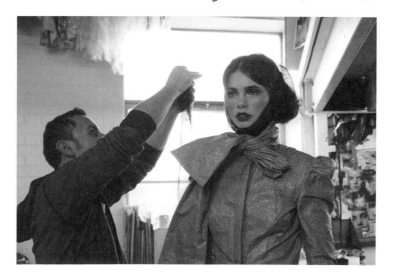

Left to right, from top:
Bora's mother Dr Birsen Aksu; Lauren Gold
models Bora Aksu's People Tree silk dress;
two shots from Bora's mainline show;
illustration, a present to People Tree to
celebrate its 10th anniversary in UK and
20th in Japan; Bora adds the final touches
backstage.

it. For example, two contrasting fabrics working together, like silk and canvas cotton. I drape it on the stand and see how it falls.

You seem to have amazing trend antennae — you are able to come up with ideas that are seen in trend books a year later.

Fashion is not so much about trends any more, it reflects more the mood of society and the world. Trend is connected with lifestyle. If you are in touch with it subconsciously, then it reflects in your work.

Who are the most famous people that wear your label?

Sienna Miller, Keira Knightley and Tori Amos, who bought an entire collection.

Do you think the fashion industry is changing? Is it becoming more reflective and interested in sustainability?

The whole world is waking up and seeing truth, beauty and the need for sustainability. For a long time it was just about indulgence. It is very exciting that this is happening. Not just in fashion – nature changes, the economy changes, and people finally realize it's not just about TAKING, or *'what about me?'*. It's not just about self-interest any more. That doesn't bring anyone happiness. People are thinking about how they can do something to make the world a better place.

We can't continue consuming the world – chewing it up and throwing it away. In my designing, as well, I am now thinking about how I can create something that can last forever – that will still be beautiful in 50 years' time. We need to bring fashion to a more intellectual level. We didn't have this before… it was all about consuming, consuming, consuming.

Your collections look timeless. But fashion requires collections twice a year — how do you feel about that? The fashion industry is, by its very nature,
unsustainable. Shouldn't good design just be used again and again?

I completely agree. But then it is the fashion industry, and there is a calendar attached to it, and if you want to be a part of it you have to work to that calendar. We can show our passion and reaction to it by creating timeless pieces and working to produce more sustainably.

You were the first designer to collaborate with People Tree for Vogue Japan. *Why?*

Fair Trade excites me! You don't get that feeling very often. Doing it – the whole process, it has a great impact on me. It's a really global thing. You create something so beautiful and it can be so relevant to everyone, even in the fashion world.

I'm working on my seventh collaboration with People Tree and still really enjoying it. Boundaries between countries seem to fall away. It is amazing that People Tree can reach out into the villages and work with cotton farmers and artisans and help them to help themselves. The more I'm involved, the more I see how hard it is. Fair Trade works extremely differently from the rest of fashion. You have to be extremely patient, extremely understanding, but the result is worth it. You need to be flexible, understand what people's skills are and what you can produce using these skills. Whether it's handweaving the fabric, their embroidery skills or their technical skills. It is not a one-way thing. Usually in fashion you just say what you want and you get it. Fair Trade doesn't work like that – it's about creating something beautiful that benefits everyone.

I'm really happy with the results and feel really lucky to be working with handwoven fabrics and organic fabrics which are difficult for me to work with otherwise. I look forward to visiting Fair Trade groups one day and designing with them in their villages.

www.boraaksu.com

Bora Aksu's 10-20th birthday celebration illustration for People Tree, AW11-12 collection.

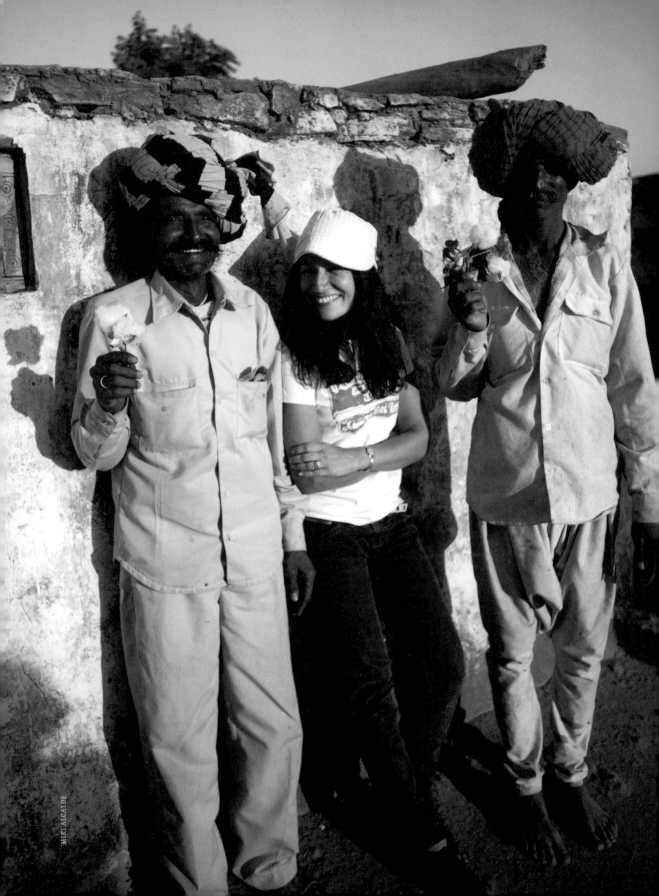

Fair Trade supply chain

Safia Minney with Fair Trade and organic cotton
farmers in Kiddya Nagar, Gujarat, India.

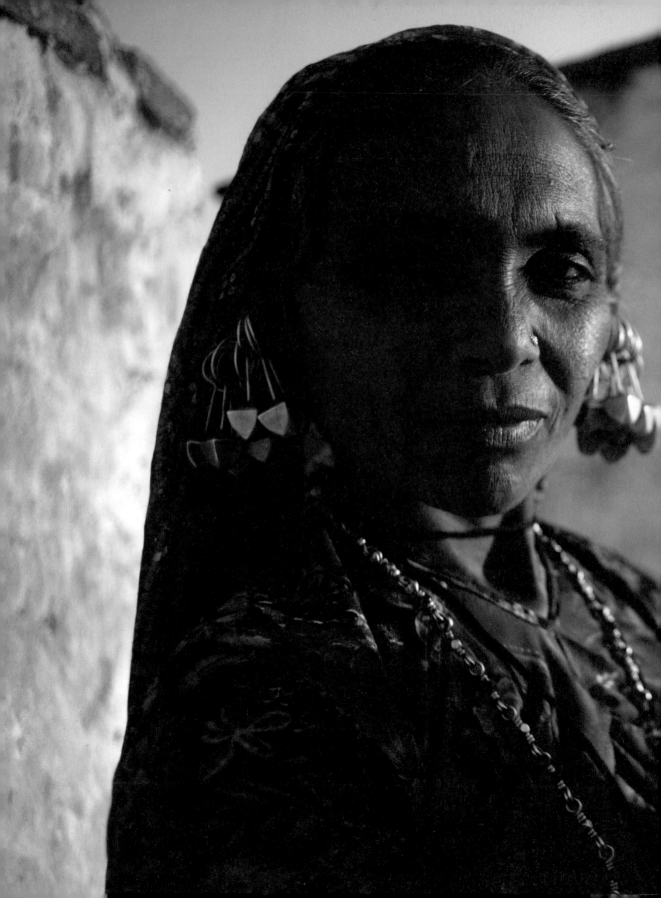

Amrut Charda holds organic cotton picked straight from the fields.

SAFIA MINNEY

The Fair Trade supply chain

Safia Minney explains why Fair Trade is so vital for small producers in Africa, Asia and Latin America – and how Western governments can help.

Conventional fashion manufacture in developing countries has become a complicated process, with different stages of production subcontracted out to smaller companies. This makes transparency and accountability challenging, as the supply chain is difficult to manage, monitor and certify.

Working in long-term business partnerships, as was typical before the era of fast fashion, involved a greater sense of partnership with suppliers. Buyers gave them long-term orders and security so they could invest in better equipment and training, and improve workers' conditions and pay. That has become rare today as buyers are pushed by merchandisers, who in turn are pressurized by management to improve margins, speed up production, minimize stock risk and improve delivery times.

Too often, the same fashion company whose website boasts an ethical trading policy – complete with photos of happy workers – is also demanding that buyers negotiate a cheaper price than the previous year. Friends in fashion companies often say: 'If merchandisers, buyers and marketers worked together in large companies, we'd see real change.' Likewise, trade union leaders who represent garment factory workers propose that buyers and people who monitor factories should meet garment factory workers off the premises and away from factory managers so as to understand what improvements need to be made.

Voluntary codes of conduct like the Ethical Trading Initiative have been unsuccessful in delivering real change within the fashion industry. Monitoring factories is inadequate on its own. All too often, the day before the auditor arrives, management announces over the tannoy what each class of workers must say their wages are and the hours they should say that they work.

What has been successful in improving pay and conditions are protests by garment workers, backed by consumers following public-awareness campaigns run by War on Want, Action Aid, People Tree and others to generate media coverage. Determined protest action last year saw the legal minimum wage in Bangladesh reviewed upwards for the first time in 10 years (wage rates were nearly doubled).

How the Fair Trade fashion supply chain started

Throughout Asia, Latin America and Africa, indigenous textiles and their hand production have always been at the heart of the Fair Trade crafts movement, but missing links of design and technical input meant that it was only recently that a fashion product could be brought to the market. Historically, a Fair Trade fashion item would have been a handwoven scarf or a simply sewn kaftan. Sustaining inputs and orders on a fast-lifecycle product while working in remote villages is costly and it is challenging to compete with conventional, mass-produced fashion.

In 1995, People Tree Japan and Traidcraft started working on an eco-textile project together, to help Fair Trade artisanal groups train to use safe azo-free dyes, ahead of new regulations to block their products from the European market. We also started to look at how to support cotton farmers to earn better prices and go organic. The first Fair Trade and organic cotton came from farmers' networks like Agrocel

in India and Sekem in Egypt – social businesses set up specifically to help farmers get a fair price and to foster rural and community development.

With both certifications in place, Shailesh Patel of Agrocel says, 'Farmers can earn 30 per cent more than they would otherwise, and the stability of the price means farmers bear less risk'. According to social businesses like Agrocel, 'We would prefer to supply our organic and Fair Trade cotton to Fair Trade-supported handweavers, so that they can get the benefit of work through weaving it'.

It is in this spirit that Agrocel and People Tree partnered to train Bangladeshi agriculturalists in Fair Trade and organic cotton farming, to transfer knowhow to Bangladesh, and at the same time sent the first shipment of Agrocel organic cotton to Bangladesh to put on the handlooms. The tailored pieces then made were beautiful, but as Fair Trade groups are in villages rather than export-processing zones, they could not qualify for the tax and duty advantages that big factories enjoy, and this made the costs prohibitive. People Tree is now setting up a company to buy yarn in bulk for Fair Trade producers, and ultimately to import organic and Fair Trade yarn – this will help both the farmers in India and Fair Trade groups in Bangladesh.

Fair Trade organizations, whether in the Global North or the Global South, work to World Fair Trade Organization principles. They are required to conduct social reviews against these and to be inspected independently. A framework for Fair Trade is now being developed by People Tree to help build business capacity and technical skill amongst partners in Bangladesh. Once a process has been tested and a manual created, this resource will become useful to others in fashion who want to work with Fair Trade groups in rural areas. What is clear is that better incomes and conditions come with long-term planning, and fashion will have to change its pace and adjust its relationships if it is to improve conditions for workers and increase employment.

Government regulation should prevent the worst practices in fashion and should direct additional investment and support into Fair Trade and ethical fashion to help it grow. While conventional fashion companies are not being held accountable for meeting environmental and labour laws throughout the supply chain, supporting ethical fashion by cutting duty and sales taxes would go a long way to levelling the competitive playing field in the marketplace. Despite everything, the pioneer brands are running on passion and supported by a growing number of loyal customers – but it isn't easy.

Buyers and producers working in long term partnership = sustainable trade.

MIKI ALCALDE

Here are some of the People Tree symbols you'll want to look out for. Other retailers are beginning to use similar ideas to communicate the unique skills being used.

WFTO – World Fair Trade Organization
WFTO's mission is to improve the livelihoods and well-being of disadvantaged producers by linking and promoting Fair Trade organizations, and speaking out for the greater justice in world trade. WFTO has more than 450 members in 76 countries across the world.

Fairtrade Standards for cotton farmers
Organic cotton fibre that is certified organic and Fairtrade. The FAIRTRADE mark is a guarantee that small-scale cotton farmers in developing countries receive a fair and stable price. They also receive a premium payment for community development projects and education.

Organic standards in garment production
Organic cotton that is not only grown to meet organic standards – the garments are also manufactured to meet organic standards too. The Soil Association symbol guarantees products meet the Global Organic Textile Standards (GOTS), ensuring environmentally friendly processes in tailoring, spinning, knitting fabric, transportation and storage.

Organic standards in cotton farming
Cotton produced to international organic standards by Control Union and Ecocert. This guarantees that cotton has been grown to strict organic standards. Protecting the farmers' health, land and water from pollution, promoting sustainability.

Handwoven
One piece of clothing made on a handloom employs 10 more people than making it on a machine. One handloom also saves 1 tonne of CO_2 per year.

Handknit
Handknitting of clothing and accessories promotes livelihoods as well as creating jobs preparing wool, cotton, banana, silk and hemp fibres.

Hand embroidered
Fair Trade groups work with hand embroidery artisans to create livelihoods while keeping traditional skills alive.

Hand block printing
Hand block printing techniques create jobs for artisans and offer a unique print look.

Hand skills

Hand skills such as weaving and embroidery promote livelihoods in rural areas for artisans and subsistence farmers all over the developing world. There are 10 million living by such hand weaving in India and Bangladesh alone. The production of fabric using a handloom rather than a machine saves one tonne of CO_2 per year. Which means that if we Western consumers switched to buying Fair Trade, handwoven fabric, not only would millions of families be lifted out of poverty and be able to send their children to school, but we would also be reducing global warming by using people's hands and physical energy rather than oil to produce cloth.

Hand skills mean the most economically marginalized people in rural areas can earn a decent living without leaving their families to migrate to cities in search of work. That's why Fair Trade clothing favours production that involves hand skills.

Although we cannot go back to making all clothing as it was before the Lancashire power mills of the late 19th century, it still can be found in rural pockets of the world. An Indian village or an indigenous hill group in Laos will grow the cotton organically, hand spin the short fibre into a thread, then weave the thread into cloth on a small handloom. The cloth is then dyed with natural indigo, which makes the fabric more durable, and the pieces, often square, are stitched together into clothing and embellished by hand with embroidery. This would be a relatively easy process to support, monitor and certify, and some Fair Trade groups function in a similar handcraft-intensive way, producing everything locally.

The Fair Trade supply chain celebrates hand skills; their added value creates unique products while sharing the benefits of trade with the largest number of people.

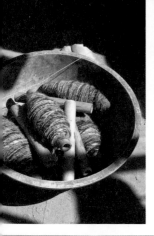

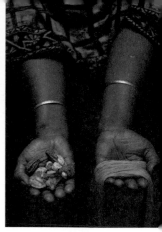

Left to right: Natural alpaca yarn is hand spun into bobbins by indigenous people in Peru; Silk produced by hand in India, Bangladesh and Laos, providing valuable incomes; Organic cotton bobbins produce a fine organic cloth; Reviving natural dye and techniques – hortoki seeds and dyed yarn at Swallows, Bangladesh.

Left to right: Roksana bobbining in preparation for hand weaving; Ayesha hand weaves at Swallows; At Brindaban Printers, supported by SASHA India, handmade blocks are prepared.

Left to right: Traditional hand embroidery in the Bhuj area of Gujarat, India; Batik fabric painting at KVSC, India; Brindaban Printers hand blocking a traditional motif in Calcutta, India.

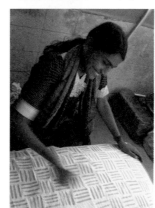

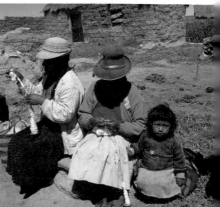

Left to right: Button making at New Sadle, Nepal. Bone buttons are individually carved by hand. Buttons are made of natural biodegradable materials like nut, coconut, shell and bone; Indigenous women in Puno, Peru hand-spin organic cotton and alpaca fibres before handknitting a sweater.

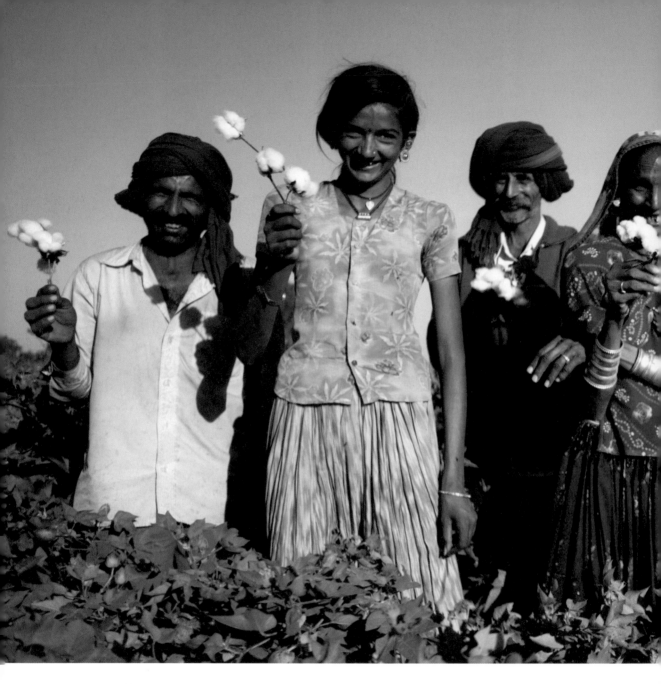

Producer profile: **Agrocel**

Agrocel supports over 40,000 farmers who are organized into local groups over five states of India. Around 95 per cent of Agrocel farmers work manually, from ploughing to harvesting, with little or no machinery. Each of the processes is labour-intensive and Fair Trade and organic farming maximizes the number of people employed.

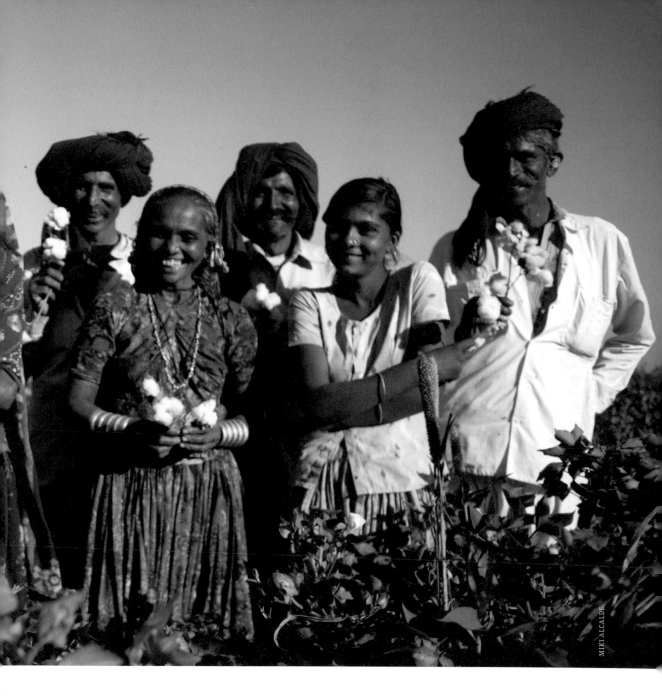

MIKI ALCALDE

The people above are from Rappa, Gujarat, where 1,005 farmers are supported by Fair Trade and 672 farmers are also organic-certified. In 2009-10 the organic premium paid to the farmers here was £20,000 ($32,000) and the Fair Trade premium was £67,000 ($107,000). This premium makes a huge difference. In Rappa, this was spent on repairing the local pond, the only source of water for drinking and bathing, benefiting 1,600 people.

Producer profile: **Agrocel**

Safia Minney speaks to Shailesh Patel, Agrocel's project manager, about the impact Fair Trade and organic has on farmers there.

Can you describe how people farm here?
Most farmers plough manually with their bullock, only big farmers have tractors. It takes more than two days per acre to plough land with a bullock.

Sowing the seeds manually then takes five or six labourers one day to do. Before the seeds are sown they are coated with organic fertilizer. This consists of cow dung, water and fertile soil or bio culture to get nitrogen into the soil. This is mixed with the seed to coat it.

What do you use instead of synthetic pesticides?
It takes two to three days to make the pesticides. These are made from the neem plant. Neem leaves and neem oil (made from crushing the seeds) are mixed with fermented buttermilk, cow urine and water and used as a spray. Twenty millilitres of neem oil is used per litre and the fields are sprayed four or five times for each crop. It takes more than a day of solid work to create enough spray to cover one acre.

What was life like for farmers before Agrocel?
Farmers felt very isolated. They had to travel a whole day just to buy basics like sugar and taking their cotton to market to receive a fair price was really hard and weakened their ability to negotiate a good price.

In India the population is increasing, unlike China where it is decreasing, so people's hands are the most valuable resources India has. What part does organic agriculture play in this?
For many years, India has been dependent on agriculture. Most employment is through agriculture. There is now a desperate need to do things differently as the situation is not good for the farmers. Many cotton farmers are not growing good crops and are using expensive fertilizers and pesticides. If we do proper planning and development activities like Fair Trade we can change this.

> In rural areas like this women have little opportunity to talk to anyone outside the family, so their group training sessions make a big difference

Is there a danger that Indian people will want more and more material things and adopt the Western model?
Indian culture is different. Living in large families and in villages means that Indian people are more connected with each other. The village barber, for example, is like part of our family. He cuts the hair of all the men in

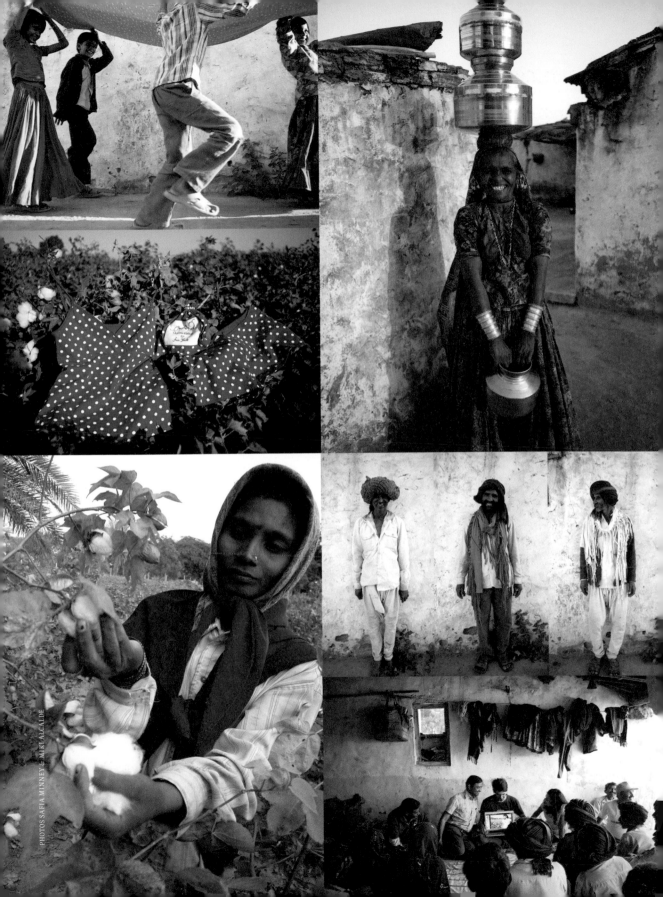

the family and attends important ceremonies in our lives – like weddings, for example. If he has a problem with his health, we have a responsibility to look after him. This relationship has been there for generations. We give him presents during festivals. It's like this with many members of the community. These relationships are what's important, not material things.

Agrocel collaborates with People Tree to train Bangladeshi farmers in organic agriculture and to transport organic cotton to Bangladesh to be hand-woven and hand-embellished. Why do you help us when you could compete simply by selling your cotton at a good price to a factory?

Hand production helps communities. Our company wants to help not only the farmers but the workers, weavers, dyers and embroiderers. There has been a bitter cycle of modernization in India. You can only teach the young new skills; old people do not have time to learn new skills, they have not got the time to learn them thoroughly. Older people know the traditional skills and can utilize these.

Agrocel is very interested in sustainability and development. Hand weaving does not damage the environment; people's hands do not do damage like machines do. A farmer's bullock eats the grass and gives you dung, which is useful and important for the future of the farmer, whereas a machine eats oil and gives off CO_2 which damages the planet. This is why it is important to support these kinds of hand skills.

Agrocel runs on 'Gandhian economics'. Had Gandhi been sitting next to you at the People Tree fashion show, what do you think he would have thought?

Difficult question! [smiles] If he had been there maybe he would have been proud that the clothes are totally hand-made. Maybe he would think 'if more people did this it would help the problem' and be very happy.

What is more important to farmers, Fair Trade or organic?

I think for these small-scale farmers, providing technical guidance and agricultural inputs at the right time and the seed at the right price to improve productivity and profitability is as important as going organic.

Tell me about the things that make you happy?

In India we believe that happiness doesn't come from possessions. Happiness is helping each other and living together. All the world is one family – if everyone helps each other that will make happiness for all.

You said recently that sometimes you sleep under the neem tree — one real pleasure that money can't buy!

Yes, when it's really hot I sleep under the neem tree in our family garden. It uses no energy and is a wonderful restorative. I recommend it!

Ms Bhanuben, Project Officer

'Fair Trade premiums also support self-help groups for female farmers. There are five self-help groups with 74 members. Each member joins the savings scheme and starts their own bank account; this trains women in financial literacy and helps them save and plan.

'We teach women's health and literacy and provide training on how to make good compost and how to clean the cotton to improve its quality. In the summer season, when the women have more time, they spend two to three hours a day learning how to read and write. In rural areas like this, women have little opportunity to talk to anyone outside the family, so their group training sessions make a big difference. We also organize trips to agricultural and craft institutions where opportunities help women.'

Sangeita from Gujarat sits on a mound of organic cotton, in her Orla Kiely for People Tree organic cotton dress.

Producer profile: **TARA**

TARA Projects in Delhi, India, have led the way in protecting and supporting small groups of handicraft producers, while also campaigning against child labour and setting up tuition centres for deprived and marginalized children who have no choice but to work. TARA stands for 'Trade, Alternative, Reform, Action'. Over the page we talk to Moon Sharma, the CEO and daughter of one of the founders.

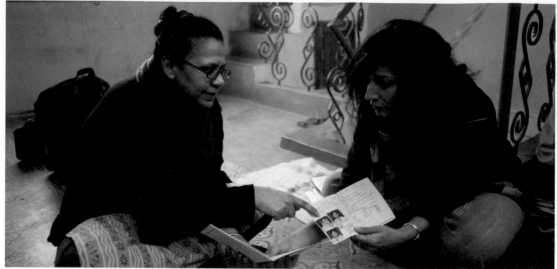

How did TARA Projects start and why did you think Fair Trade was the answer to lifting people out of poverty?
TARA Projects was started in the late Sixties as a social action by my father, Professor Sharma, Sister Stephanie Mass and other social workers. The aim was to address social evils, like the caste system, and widespread economic exploitation at grassroots level. In 1973-74 TARA Projects became involved in income-generating activities based on the philosophy of 'alternative trade' to support the most marginalized people and their development. We believed that fairness in trade could bring prosperity and peace in society. We play a vital role in improving the lives of less privileged artisans by economically empowering them and supporting them to sell their products, giving them better prices, better designs, better information and building their capacity. Many producer groups not only have better infrastructure, but also have more confidence and are more aware of their rights.

What is the most common cause of exploitation you have seen and how does TARA change this?
Conventional trade is based only on making profit. Companies compete in the market and can become tools of exploitation, where child labour is used because wages are much lower than adults' wages. There are many children who have been child labourers who are supported by TARA through its educational programme – we provide them with free education and motivate them to continue their studies. We are supporting more than 1,100 children at present. Education helps children escape from exploitation and poverty.

Are conventional fashion brands starting to be interested in Fair Trade handicrafts and accessories? What needs to happen to make the fashion industry more responsible?
Conventional fashion brands are taking more interest in Fair Trade thanks to consumer pressure and heightened awareness of the issues. They are also trying to market Fair Trade crafts through their marketing channels. They need to be more committed to support Fair Trade – to pay better prices and create better terms of trade.

So what are the key benefits of Fair Trade?
Child labour is, of course, forbidden. But also TARA artisans certainly earn more in comparison to other mainstream producers. Our workers now have better working conditions, saving schemes, health facilities and opportunities for training.

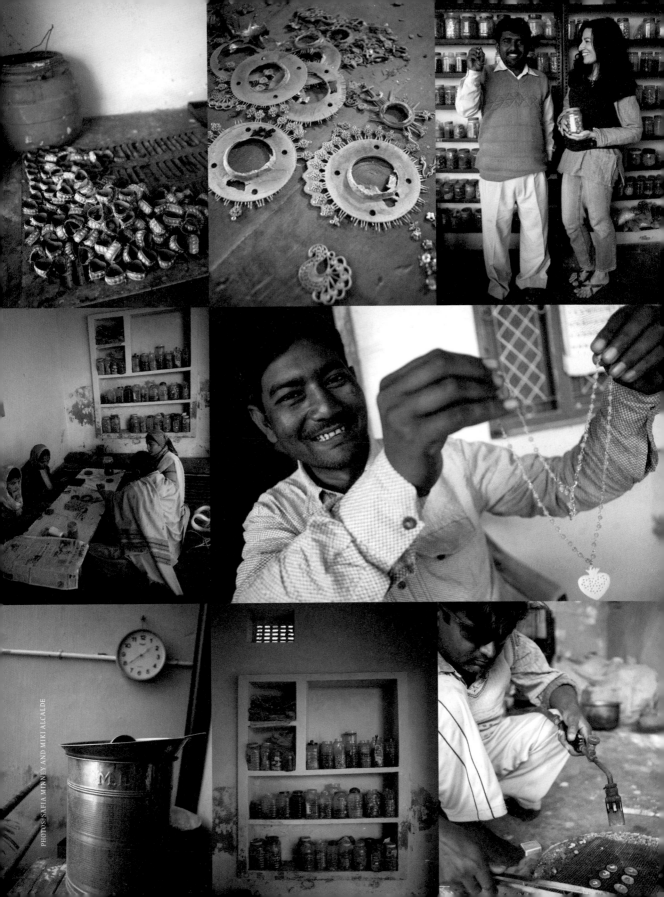

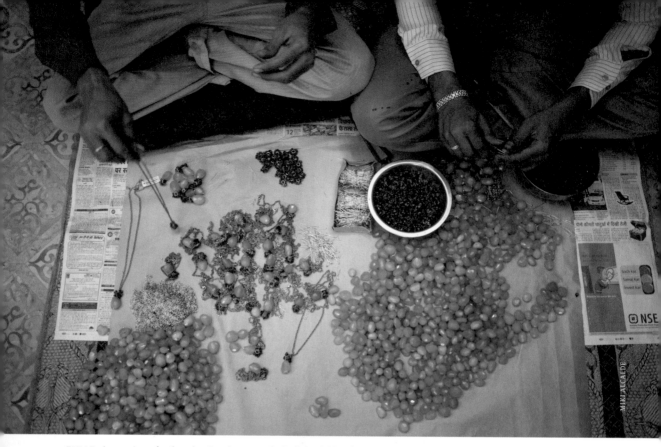

MIKI ALCALDE

TARA Projects supports family and artisanal groups and schools for children from low-income families in the slums of Delhi.

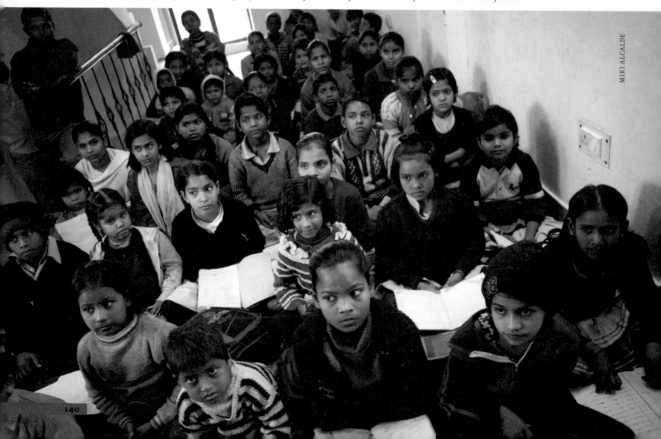

MIKI ALCALDE

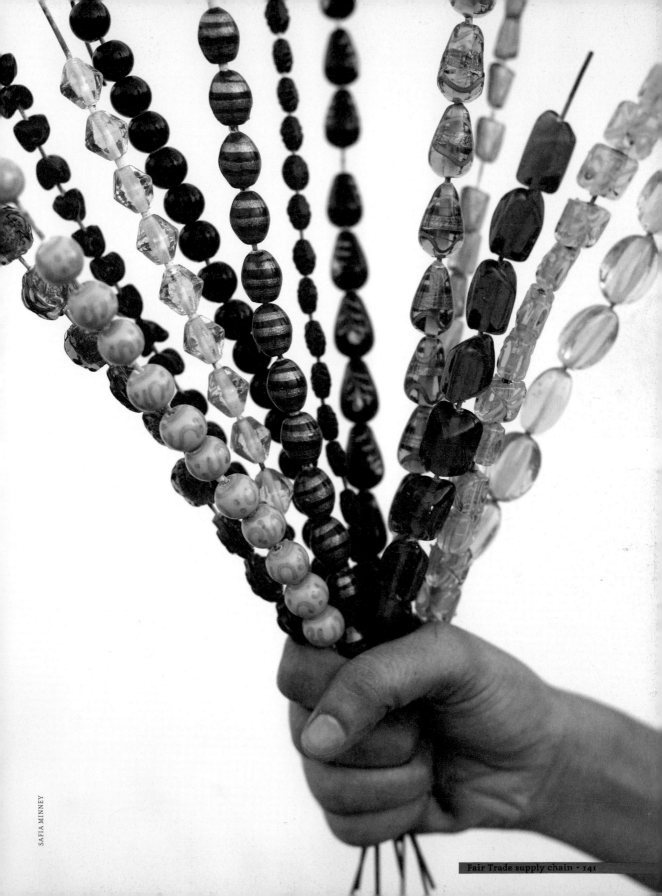

Monju Haque *is founder of Fair Trade organization Artisan Hut, Bangladesh.*

Tell us about the experiences that led you to set up the Fair Trade organization Artisan Hut?

Initially, I worked in Dhaka on government projects. After that, I started helping local NGOs. In both cases, I quickly became disillusioned because I felt that our initiatives were badly managed. Benefits were not reaching the communities who so desperately needed our help.

Finally, I got involved with local income-generating activities which focused on teaching women embroidery. I enjoyed my work much more when I saw poor women beginning to generate their own livelihoods. Some women did very well while they were training, but could not manage to find a good market for their product afterwards. Despite this, I felt really happy when I saw these women earning money by selling firewood, local cakes or handicrafts, for example. Even though they didn't necessarily use the skills they learned at our project, they had gained confidence and were earning their own living.

Soon I realized that, by helping people to create their own businesses, we were enabling them to maintain their family – maybe even earn enough money to send their children to school or afford basic healthcare.

Inspired by the potential for change, I established Artisan Hut in 2002 based on the Fair Trade business model. We started with hand weavers who were losing their jobs to machine-powered looms.

What are the environmental and social advantages of hand-loom weaving?

Hand-loom fabrics are very comfortable to wear, and save carbon dioxide in the production process. We need to give employment to Bangladeshi people, not take it away. A power loom takes three times less personpower than a hand loom. We are able to add value with hand embroidery. Many women learned these skills from their grandmothers and mothers at a very young age – they are part of our tradition. For generations, Bangladeshi women have been producing sarees and lungi [loincloths traditionally worn by men] by hand.

Nowadays, handicraft work is increasingly valued in world markets. People appreciate the uniqueness and quality of the handmade garments. It is important to keep these skills alive.

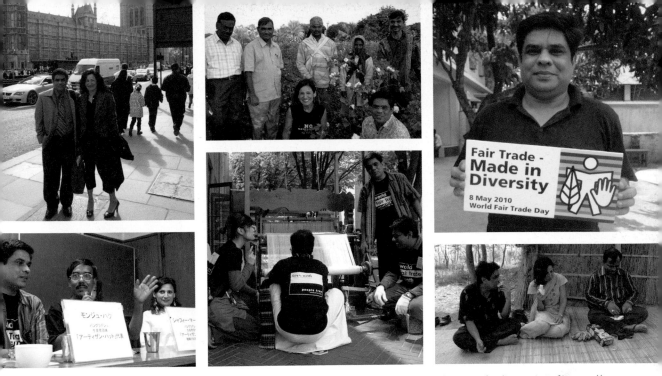

*Clockwise from left: Monju in the **UK** as a witness to International Development Committee on Fair Trade at the Houses of Parliament; in **India** working with People Tree to set up the Fair Trade and organic cotton supply chain for Bangladesh; promoting World Fair Trade Day; relaxing with Fair Trade friends Raihan and Safia in a village in **Bangladesh**; setting up a hand loom; and speaking in **Japan** to promote handweaving.*

How did you adapt these skills to the high demands of the Western market?

We did this with the help of People Tree and its Fair Trade initiatives. We received technical and design support, education on quality, communication, market awareness and exposure trips. Most importantly, we learned how to maintain Fair Trade compliance for the well-being of artisans. People Tree made a huge investment to help poor, disadvantaged artisans when other commercial buyers looked the other way.

What are the global benefits of Fair Trade?

Fair Trade business is development work in the purest sense – after a relatively short period of time, there is a return on investment. This is a very different scenario to governments, companies and individuals simply donating aid. When Western consumers buy Fair Trade brands they are directly supporting developing countries with a network of sustainable, self-sufficient communities.

Fair Trade business particularly benefits the rural areas where the artisans live. It means they do not have to leave their families and children and migrate to the big cities and live in slum conditions to find work.

What are the main problems facing the existing textile industry in Bangladesh?

Around 80 per cent of Bangladesh's GDP is earned from factory-made garments for export. This is very, very important income for the country. However, there are inadequate regulations in the industry and most of the benefit is in the hands of a very few. Millions of workers are underpaid and they live in inhumane conditions with water pollution and lethal gas and electricity supplies to the slums in which they live. People are forced to work long hours and they become ill. I eagerly want to know the health position of women after 10 years' work in a Bangladeshi garment factory. I ask industry leaders this question, but they do not know the answer. There seems to be no plan to help them. I think Fair Trade provides a real alternative and I love to see people working with real dignity and pride.

Fair Trade Principles

from the World Fair Trade Organization

1 Creating opportunities for economically disadvantaged producers

Fair Trade is a strategy for poverty alleviation, economic empowerment and sustainable development. Its purpose is to create opportunities for producers who have been economically disadvantaged or marginalized by the conventional trading system.

2 Transparency and accountability

Fair Trade involves transparent management and commercial relations to deal fairly and respectfully with trading partners and all stakeholders.

3 Fair trading practices

Fair Trade concern is for the social, economic and environmental well-being of marginalized small producers. It does not maximize profit at their expense and is responsible and professional in meeting its commitments in a timely manner. Suppliers respect contracts and deliver products on time and to the desired quality and specifications. Fair Trade buyers, recognizing the financial disadvantages producers and suppliers face, make prompt payment and a pre-payment of at least 50 per cent if requested.

The Organization maintains long-term relationships based on solidarity, trust and mutual respect that contribute to the promotion and growth of Fair Trade.

Fair Trade recognizes, promotes and protects the cultural identity and traditional skills of small producers as reflected in their craft designs, food products and other related services.

4 Payment of a fair price

A fair price is mutually agreed through dialogue and participation, which provides fair pay to the producers and can also be sustained by the market. Where Fair Trade pricing structures exist, these are used as a minimum. Fair pay means provision of socially acceptable remuneration (in the local context) considered by producers themselves to be fair and which takes into account the principle of equal pay for equal work by women and men.

5 Ensuring no child labour and forced labour

The Organization adheres to the UN Convention on the Rights of the Child, and national and local law on the employment of children. The Organization ensures that there is no forced labour in its workforce and/or members or homeworkers.

6 Commitment to non-discrimination, gender equity and freedom of association

The Organization does not discriminate in hiring, remuneration, access to training, promotion, termination or retirement based on race, caste, national origin, religion, disability, gender, sexual orientation, union membership, political affiliation, HIV/AIDS status or age.

7 Ensuring good working conditions

Fair Trade means a safe and healthy working environment for producers. It complies, at a minimum, with national and local laws and ILO conventions on health and safety.

8 Providing capacity building

Fair Trade seeks to increase positive developmental impacts for small, marginalized producers through Fair Trade by developing their skills and capabilities.

9 Promoting fair trade

Fair Trade organizations raise awareness of Fair Trade and the possibility of greater justice in world trade. They provide their customers with information about the Organization, the products, and in what conditions they are made. They use honest advertising and marketing techniques and aim for the highest standards in product quality and packing.

10 Respect for the environment

Fair Trade products maximize the use of raw materials from sustainably managed sources in their ranges, buying locally when possible. They use production technologies that seek to reduce energy consumption and that minimize greenhouse gas emissions. They seek to minimize the impact of their waste stream on the environment. Fair Trade agricultural commodity producers minimize their environmental impacts by using organic or low-pesticide-use production methods wherever possible.

See www.wfto.org for full details

Making Fair Trade fashion happen

Tracy Mulligan
Head of design, UK

I'm head of design at People Tree. The main difference between Fair Trade and conventional fashion is our focus on supporting our Fair Trade partner groups. We select from fashion forecasters the trends which most suit the hand skills of our partners, which is the other way round from the mainstream. We select yarns, weaves and colours, and design the prints and embroideries ourselves to ensure that we can give work to our partners. So we are almost a textile and fashion business.

My career started with a bang! I started my own business straight out of St Martins [College of Art and Design, in London] and was lucky enough to be one of the first London Fashion Week New Gen designers. It was a great time in British fashion – very exciting, lots of hard work.

I love designing every day, in my imagination and on paper, and realizing an idea into a real product that people get to enjoy and wear for their everyday lives. It is this challenge that means a career as a fashion designer is never boring.

Ruth Valiant
Garment technologist

In Fair Trade fashion, you first have to assess the producers' skills and capabilities. For example, if a style requires embroidery, block printing or construction skills, it is important to choose the right producer, as some groups are much stronger in certain areas than others.

People Tree works very closely with the producers, training them to improve their skills. They use many hand skills which make our clothes unique and mean that nearly every single piece is slightly different. We also use natural fibres and take great care to ensure that all our processes are as eco-friendly as possible. This is a more time-consuming and difficult process than conventional production, but it is rewarding – putting people and their skills first. We visit the producers often and I really enjoy these trips; I see them improve their skills and confidence season by season and that is very satisfying.

I feel passionate about the producers I work with – people should not be exploited and their environment destroyed just to give us cheap clothes.

Jenny Hulme
Buyer

I studied Fashion and Textiles at university and decided to pursue a career in fashion buying. My first job was working in a small high-end fashion boutique. After 18 months, I applied to be a Buyer's Admin Assistant at my favourite high-street shop, Topshop. I ended up working there for five years. As time went by, I became more and more interested in Fair Trade and ethical production and wanted to try working for a smaller company. I already knew about People Tree and liked what they stood for so when I saw a buying position come up I applied straight away.

For anyone wishing to work in Fair Trade, I would recommend getting some experience working at a conventional fashion company first. The training I received at Topshop has been completely invaluable in teaching me all the skills I need to be a buyer.

Product development for People Tree is all about making the most of our producers' skills and developing a unique handwriting, rather than following the latest trends.

Misato Koizumi
Designer

I was always interested in environmental issues. I used to get upset about waste and excessive packaging. I've studied fashion design in Tokyo and London and also been a tailor in Tokyo so I'm quite practical and hands on.

I wanted to design clothes, but in a way that was environmentally friendly. When I found People Tree, I realized I could do this. That was 10 years ago in Japan.

At the time I didn't know much about garment factory worker exploitation, but through my work at People Tree, I got to learn more about what Fair Trade really means and the difference it makes.

I find using hand skills, natural and organic materials an incredibly creative process – designing the fabric and prints from scratch, rather than just buying them in.

Every year we're strengthening the collections, gaining more experience and empowering Fair Trade groups to improve their skills – I love being a part of this process.

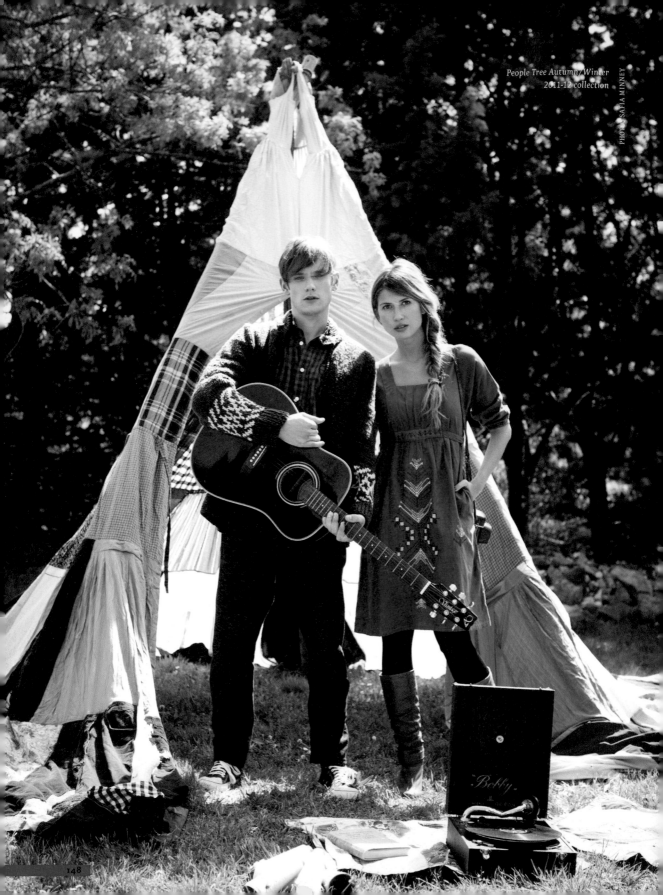

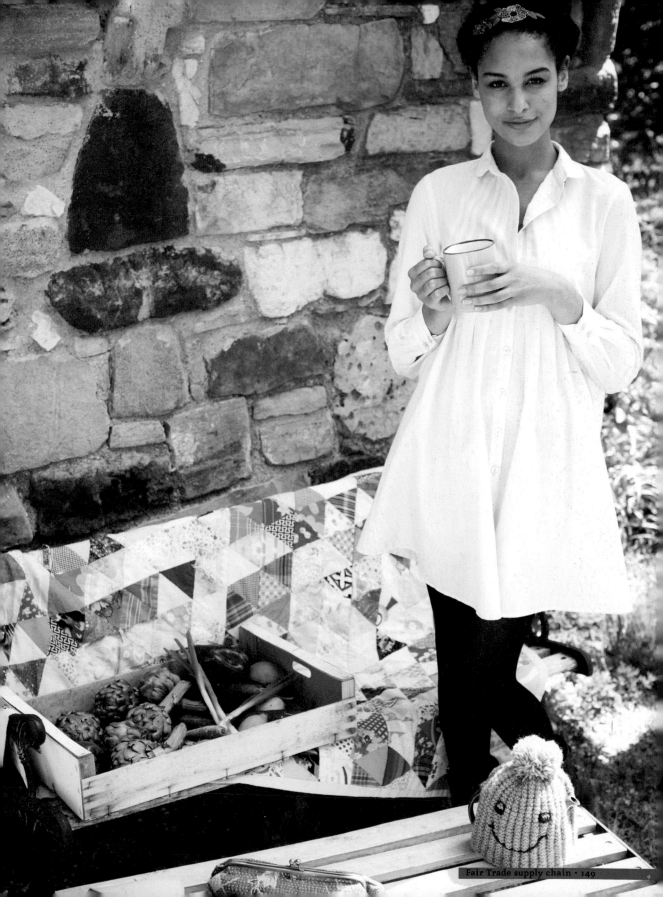

People Tree Japan and
UK spring/summer
2012 collection

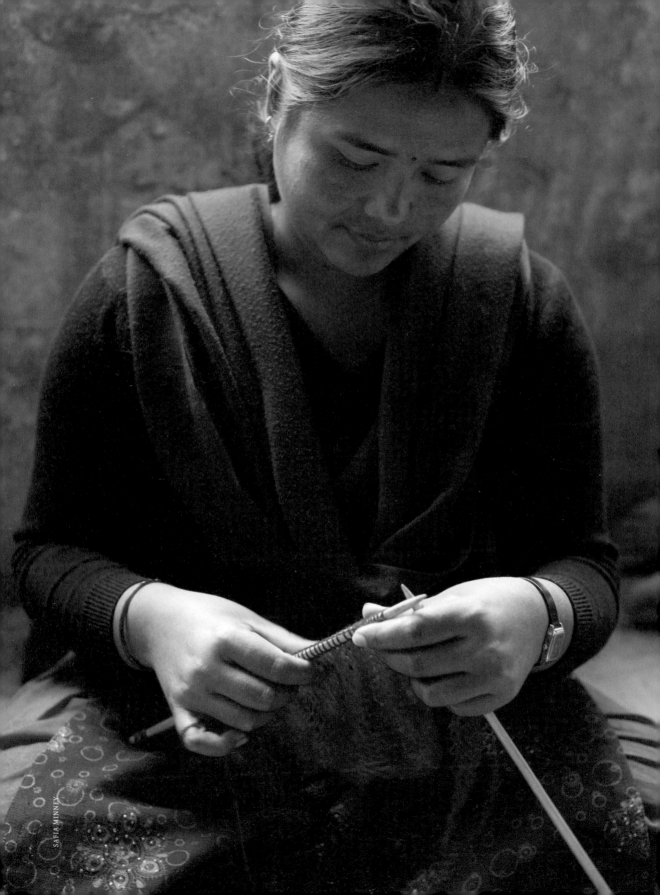

Changing the industry

*Handknitting a sweater for
People Tree, KTS, Nepal.*

Jane Shepherdson

CEO of Whistles, the cutting-edge premium high-street brand.

Why were you so quick to pick up on Fair Trade and ethical fashion?

At Topshop, we had been exploring different ways of working with our manufacturers, and had embarked on a three-year programme, starting with the mapping of our supply chain and leading to a wholesale review of our buying processes. I needed to learn more about the Fair Trade fashion business model and I knew that People Tree were the brand to turn to – if anyone could make commercial sense out of ethical fashion, it would be them! They have a combination of real passion for design and the absolute certainty that this is the right way to do it…

What do you see as the biggest environmental and social issues in fashion today?

The amount of clothes that we buy and throw away, sometimes unworn, is quite disgusting. It has almost become an addiction. People struggling under the weight of six or seven carrier bags filled with clothes is not an uncommon sight on any British high street. I thought that the recent recession would have changed the way that people shop, but I think it has merely pushed them towards even cheaper clothes. The price of clothing is unsustainable and unrealistic. The working practices in most large factories producing for the lower end of the high street are unacceptable, and yet they are well documented and reported. The only conclusion that can be drawn is that most people don't care, and would rather have their fix of new clothes, than consider how or who could have made them for that price.

People Tree has proved that it is absolutely possible to make a profit while paying cotton farmers and producers of clothing a living wage as well as using environmentally sustainable materials and processes. Why don't more brands do it?

Fair Trade, sustainable fashion requires a huge amount of commitment and resources in an arena where many retailers have succeeded in making large profits relatively easily, and have given their shareholders an expectation of more to come. Until the consumers tell them that they don't want that any more, why would they change? Right now, consumers really don't seem bothered, and the cheaper it is, the more they are buying.

I wonder if legislation is the answer? My concern is that all of these retailers already have their own 'codes of conduct' – many are members of ethical groups who purport to monitor their activities – and yet there always seem to be manufacturers who have 'slipped through the net'.

To produce and sell completely Fair Trade clothing is not easy, as I have discovered in my

Jane meets the children at a day care centre supported by Fair Trade.

SAFIA MINNEY

time working as a Trustee of the People Tree Foundation. However, there are measures that the big retailers could start introducing that would make a big difference – paying a living wage being the most basic. Consumers need to make this happen.

What would it take for Whistles to go entirely Fair Trade and ethical in the next 10 years?
We're working towards becoming a truly ethical retailer. It is easier for us than for a larger retailer, as we only have 30 manufacturers to manage, though we have little influence for the same reason. We have a programme in place that addresses all of the outstanding issues facing us, and we are working through it.

How did you feel when Emma Watson voluntarily modelled and promoted Fair Trade fashion? Does this signal a change amongst the next generation?
It is so important that incredibly high profile people like Emma Watson are endorsing Fair Trade clothing, as she speaks for a generation

of women who will perhaps start to change the status quo and make demands on retailers to change their ways. She is a great role model, and certainly seems to be serious about trying to bring about change.

You visited some of People Tree's Fair Trade groups – what surprised you most?
How much the women have learned from People Tree, without which, they would not be able to produce for this market. I was also struck by the sense of community, and the dignity of the women.

Harold Tillman, Head of the British Fashion Council, said he'd like to see no VAT on ethical and Fair Trade clothes, to help promote it and enable it to compete with conventional fashion. Do you think this is a good idea? What other initiatives could leading fashion institutions take to promote sustainable fashion?
I think it's a great idea, and it would make a big difference to the perceived value of Fair Trade clothing. How about fashion institutions setting up bursaries for designers wanting to work in this field?

How should Fair Trade and ethical fashion brands popularize their message and promote themselves?
Design and integrity! It is unfortunately true that most 'ethical' fashion companies produce clothes that aren't as good as they should be both from a design and production point of view. This needs to change, so that people can choose ethical because they love the clothes, not because they feel they ought to.

What advice would you offer to young men and women entering the fashion industry today?
Don't be afraid of trying to do something different. Fashion is all about change, so you could be the person who changes it for everyone.

Melanie Plank

Trend analyst for WGSN, the leading online research service for the fashion industry.

What is a trend forecasting company? How much is analysis of cultural and social trends and how much is creating a self-fulfilling prophecy?

A trend forecasting company is an old and established part of the fashion business, going back to the end of the 19th century, when Parisian textile manufacturers would show their couture customers the key colours and fabric designs for the upcoming season.

Nowadays, trend forecasting has gone global, with many, such as WGSN, established as an online resource. It is an information and inspiration service to the fashion and style industries. Used particularly by designers and buyers, it provides them with key research and analysis by industry experts regarding key shapes, details, colours and themes for the upcoming season, which they can then apply to their own product ranges. It is also so much more than that, with analysis of everything from beauty to visual merchandizing to consumer trends and retail.

Cultural and social research and analysis underpins everything that we do, adding depth and integrity to the trends. We look to the catwalk, of course, but it is this initial early research that guides us in our analysis of catwalk and product design. I don't regard it as a self-fulfilling prophecy because, with or without trend forecasting services, the trends would continue to evolve and designers would continue to produce designs for consumers to purchase. Trends are in the zeitgeist: sure, we report on and can highlight the significance of trends to our clients but we do not create them.

Can a trend forecasting company help fashion retail businesses to think globally and sustainably? If so, how?

Sustainability has become an increasingly important trend over the last decade and is something we have covered in detail from consumer trend analysis to profiling sustainable brands such as People Tree to offering in-depth reports detailing the latest developments in sustainable textiles. We have a dedicated sustainable area in our Materials directory and offer vintage reports such as our Vintage at Goodwood feature. We also incorporate sustainable messages within our themed trend collections such as Humble Luxe, a trend that focused on using beautiful organic and non-dyed greige fabrics to create a luxury, tailoring story.

How sustainable is it to create trends? How could handicraft, which is slower to produce, ever compete with the lead times of fast fashion?

Handicraft, with its slower lead times, will always find it difficult to compete with fast-fashion retailers who are able to respond incredibly quickly to changing trends. Trends for particular products can change rapidly, with items selling out faster than buyers or designers anticipated. For handicraft producers it will always be difficult to react quickly to maximize on fast sell-throughs.

However, I believe hand-produced products can offer an alternative which customers who appreciate workmanship and craft skills will always adore and wear with pride. Using timeless style in hand-crafted production adds longevity in terms of its product life-cycle and it's usually biodegradeable too.

DAVE REFFELL

Trends information can offer a source of inspiration and direction to handicraft producers and designers just as much as to fast-fashion chains. An awareness of trends is key for artisan producers to ensure their products appeal to overseas customers and reflect consumer tastes.

What changes would you like to see?

I would like to see a wider range of customers learn to see the value and beauty of handicraft products. I worked in Cambodia for over two years with small, Fair Trade, handicraft producer groups, and seeing the days of work and skill that can go into producing just one metre of handwoven cloth has given me a real appreciation of handicraft products.

I would also like to see more brands working with handicraft producers to incorporate their skills into fashion-forward collections both at the mass-market and luxury ends of the market. Designers are often inspired by indigenous design and 'ethnic' trends but use cheap factory production to mimic handicraft techniques. It would be amazing if they could work with artisan groups, so that the benefits of trade could reach those whose heritage provides designers with such a rich source of inspiration.

High-end brands such as Prada are beginning to see the benefit to both customers and producers of sourcing high-end quality crafts from their original source. Prada's 'made in' collection is just one example of how a mainstream designer label has come to incorporate handicraft into its collections.

Claire Hamer

Buyer at a leading on-line fashion retailer.

What awakened you to the need for more sustainable fashion?

I love working in fashion; I absolutely adore it. When I was buyer at Topshop, I dealt with clothing supply chains and the way products are made. I became worried about issues surrounding 'fast fashion' and I felt I wanted to make a difference. I focused on the idea of a yoga collection for Topshop using organic cotton. Once again, my research brought to my attention the terrible suffering of millions of conventional cotton farmers across the developing world. More than ever, I wanted to do something to help, so I contacted the Fair Trade Foundation and eventually met the team at People Tree. This was an exciting but challenging time – sourcing organic cotton at the right price for the Topshop customer was not easy.

In order for the Fair Trade Foundation to endorse the work Topshop was doing, we had to make a long-term commitment to Fair Trade cotton – it couldn't be something we were committed to for just one season… It actually took a year and a half for Topshop to get accreditation. During this time, I was able to travel and visit all the different elements of the supply chain across India. In the meantime, we got a People Tree concession into our Oxford Street store.

I looked at ways to create change within the company - an intrapreneur. It was an ambitious project and very rewarding. It's quite unusual for a fast-fashion buyer to really understand a supply chain, because the emphasis has been so heavily focused on the consumer.

SAFIA MINNEY

People often ask me if they should work for a smaller company which shares their ethos, or try to change a bigger company. Obviously both are incredibly important.

Tell me how you went about making changes, first at Topshop and now at ASOS.
In huge businesses, it's all about communication. The process of sourcing a garment is very complex, involving a lot of different departments. Getting them all to work together to the principles of *'people, planet, profit as well as product'* requires a lot of nurturing of relationships. I would recommend this strategy to anyone who is trying to make changes from within a bigger company.

For example, working in conventional fast fashion, the buying department doesn't have enough time to spend with marketing informing them of the stories behind the product – they need to just work with the design team and focus on creating beautiful products the consumer will buy. But, when it comes to selling ethical fashion, there is huge value in telling the story behind a product. We need to give our customers an understanding of how a product is made – hand-printed and hand-woven rather than machine-made. The human story behind the products is so compelling.

With ASOS Africa half the job is making sure you've got a great collection but the other half is making sure that everyone – internally and externally, the consumers too – understands what has gone into that collection to make it happen. How it's made, what the advantages are, exactly how it all works – that's the new business model that the larger fashion brands need to adopt.

Another difference between ethical fashion and fast fashion is that buyers in fast fashion are used to reacting very quickly to change. In ethical fashion, decisions have to be more carefully thought through – strategies need to be developed over years. In order to make ethical fashion profitable and therefore sustainable, buyers have to understand what everybody does and how we can work together – design, garment technology, merchandising, press and marketing – we need to create a forum to help buyers and future buyers understand supply chains. For example, bringing in organic cotton is relatively simple, but to manage growth and stability of orders with small producers is tricky. You have to be a buyer, garment technologist and CSR [corporate social responsibility] team all rolled into one – this is an emerging role in the fashion industry.

What I see is that we've built an industry that's very consumer-focused and has little understanding of where and how products are created – we've had to because we've focused on trading, on fashion images, on reading cultural signs. The media plays a huge part – between *Grazia Daily* and blogging, it's almost real time. 'What's on trend this hour!'

A lot of the high-end designers are ignoring trends and being 'brand character' driven. Could the high-street retailers learn from this?
I think everyone now accepts that the concept of 'cheap fashion' has run out of steam. This presents an opportunity for the fast-fashion brands to make their sourcing more ethical and sustainable. It is possible still to provide exciting fashion, but just slow it down a bit. Everyone has a part to play in that – the media, the consumers, the retailers.

MICHAEL HEILGEMEIR

Ethical brands

Menswear from Junky Styling.

Fair Trade and ethical fashion

An introduction from Safia Minney

Are they the same? Not quite. Ethical fashion emerged out of the broad school of ethical, responsible consumption. So it includes Fair Trade concerns but also encompasses organic and recycling issues, as well as paying attention to animal husbandry practices and the overall activities of a company. Today, therefore, ethical fashion includes pioneering brands working on everything from upcycling (reclaiming fabrics from second-hand or end of roll) to Fair Trade hand-knitted hats and a range of 100-per-cent organic t-shirts. What all the pioneers share is their passion to reduce the impact on the environment and to make a product that respects the person who makes it.

There is too little investment in Fair Trade and ethical fashion for there yet to be definitive studies of their environmental and social impact, but these would be very valuable for consumers to help them to shop. What is clear is that, if you're buying new clothing, you will be making a positive difference in buying a product that checks the box in as many best practices as possible. Consumer values are different too – a vegetarian may decide that buying leather shoes is less bad than plastic that doesn't degrade in 500 years , for example.

Ethical considerations and choices are therefore not always straightforward. They are about the values that the consumer holds most important to them.

Presently the World Fair Trade Organization (WFTO) is piloting a new Fair Trade management system to strengthen Fair Trade groups in the developing world. A product label system will result from this. WFTO-registered members currently use the WFTO mark only on their catalogue and other materials but not on products.

Cotton as a commodity is Fairtrade certified by the Fairtrade Labelling Organization. This includes minimum standards in the supply chain but does not guarantee ethical or Fair Trade manufacture. Initiatives like Made By are helping High Street brands to improve social and environmental standards in their factories.

Organic cotton clothing is certified by Global Organic Textile Standards and in the UK this carries the Soil Association logo. This means that all the processes of cotton farming – ginning, spinning, weaving, dyeing, printing, tailoring, storage and transportation – comply with organic standards.

Our guide to some of the pioneering brands

Ada Zanditon ● ●
Womenswear/Jewellery
www.adazanditon.com
London, UK

Article 23 ● ● ●
Womenswear
www.article-23.com
Paris, France

Annie Greenabelle ● ● ●
Womenswear/Accessories
www.anniegreenabelle.com
Leicester, UK

Aura Que ●
Bags
www.auraque.com
based in Kathmandu, Nepal

Beulah London ●
Womenswear
www.beulahlondon.com
London, UK

Beyond Skin ●
Footwear
www.beyondskin.co.uk
Brighton, UK

Bhalo ●
Womenswear/Accessories.
http://bhaloshop.com
Perth, Australia

Bibico ●
Womenswear/Accessories
www.bibico.co.uk
Bath, UK

**Bishopston Trading
Company** ● ● ●
*Womenswear/ Menswear/
Accessories*
www.bishopstontrading.co.uk
Bristol, UK

Bottletop ●
Bags
www.bottletop.org
London, UK

Christopher Raeburn ●
Womenswear /Menswear
www.christopherraeburn.
co.uk
London, UK

Ciel ●
Womenswear
www.ciel.ltd.uk
Hove, UK

Edun ●
Womenswear/Menswear
www.edun.com
Dublin, Ireland

Emesha ●
Womenswear
www.emesha.com
London, UK

Epona ● ●
Sportswear
www.eponaclothing.com
London, UK

Fifi Bijoux ●
Jewellery
www.fifibijoux.com
Glasgow, UK

Firstborn ●
Womenswear
www.notjustalabel.com/
firstborn
Sydney, Australia

Frank and Faith ●
Womenswear/Accessories
www.frankandfaith.com
Dorchester, UK

From Somewhere ●
Womenswear
www.fromsomewhere.co.uk
London, UK

Goodone ●
Womenswear
www.goodone.co.uk
London, UK

Gossypium ● ●
*Womenswear/Menswear/
Accessories*
www.gossypium.co.uk
Sussex, UK

GreenKnickers ● ● ●
Underwear
www.greenknickers.org
London, UK

Hell's Kitchen ●
Bags
www.hellskitchen.it/index
php?mode=home&lang=en
Verona, Italy

Henrietta Ludgate ●
Womenswear
www.henriettaludgate.com
London, UK

Howies ●
Menswear/Womenswear
www.howies.co.uk
Cardigan, UK

Izzy Lane ●
*Womenswear/Menswear/
Accessories*
www.izzylane.com
North Yorkshire, UK

Junky Styling ●
Womenswear/ Menswear
www.junkystyling.co.uk
London, UK

Katherine Hamnett ●
Womenswear/Menswear
www.katherinehamnett.com
London, UK

Kuyichi
Jeans
www.kuyichi.com/
Haarlem, The Netherlands

Komodo ● ●
Womenswear/menswear
www.komodo.co.uk
London, UK

Kowtow ● ●
*Womenswear/ Menswear/
Accessories*
www.kowtowclothing.com
Wellington, New Zealand

L'Herbe Rouge ●
Womenswear & Menswear
www.lherberouge.com
Louviers, France

Lu Flux ●
Womenswear/Menswear
www.luflux.com
London, UK

- ● Fairtrade certified cotton
- ● Organic cotton
- ● Recycled/upcycled
- ● Fair Trade manufacture/sustainable practices
- ● Vegan/animal husbandry
- ● WFTO members

This key is just a guide to help you to identify the types of brands that might be of interest to you

Ethical Directory

MADE ●
Jewellery/Accessories
www.made.uk.com
London, UK

Makepiece ●
Women's Knitwear
www.makepiece.com
Todmorden, UK

Miista
Footwear
http://miista.com
London, UK

Misericordia ●
Womenswear/Menswear
www.misionmisericordia.
 com/different.html
Paris, France

Monkee Jeans ● ●
Womenswear/Menswear
www.monkeegenes.com
Youlgrave, UK

Noir ●
Womenswear
www.noir.dk
Copenhagen, Denmark

Nomads ●
Womenswear/menswear/
 accessories
www.nomadsclothing.com
Launceston, UK

Nudie ● ●
Womenwear/Menswear
www.nudiejeans.com
Göteborg, Sweden

Pants to Poverty ● ● ●
Womenswear /Menswear
www.pantstopoverty.com
London, UK

Partimi ●
Womenswear
www.partimi.com
London, UK

Patagonia ●
Outdoor Leisure/Sportswear
www.patagonia.com
Annecy Le-Vieux, France

Pachacuti ● ● ●
Hats
www.pachacuti.co.uk
Ashbourne,, UK

People Tree ● ● ● ●
Womenswear/Menswear/
 Accessories
www.peopletree.co.uk
London, UK & Tokyo, Japan

Prophetik ●
Womenswear
www.prophetik.com
Tennessee, US

Seasalt ●
Womenswear/Menswear/
 Accessories
www.seasaltcornwall.co.uk
Penzance, UK

Sonya Kashmiri ●
Bags
www.sonyakashmiri.com
London, UK

Stewart and Brown ●
Womenswear
www.stewartbrown.com
California, US

Stighlorgan ●
Bags
www.stighlorgan.com
London, UK

Study NY ●
Womenswear
www.study-ny.com
New York, US

Skunkfunk ● ● ●
Womenswear/Menswear/
 Accessories
www.skunkfunk.com
Gernika-Lumo, Spain

Tara Starlet ●
Womenswear
www.tarastarlet.com
London, UK

Terra Plana ● ●
Footwear
www.terraplana.com
London, UK

The North Circular ● ●
Knitwear
www.thenorthcircular.com
Rutland, UK

The Social Studio ● ●
Womenswear/ Menswear and
 design space
http://thesocialstudio.org
Collingwood, Australia

Toms Shoes ●
Footwear
www.toms.com
 (for US and Australia)
www.tomsshoes.ca
 (for Canada)
www.tomsshoes.co.uk
 (for UK)

Traid Remade ●
Womenswear/Menswear/
 Accessories
www.traidremade.com
London, UK

Tumi ●
Accessories
www.tumi.co.uk
Bristol, UK

Veja ● ●
Accessories
www.veja.fr/#/collections
France

Vivobarefoot ● ●
Footwear
www.vivobarefoot.com
London, UK

Worn Again
 Womenswear ●
Menswear/Accessories
www.wornagain.co.uk
London, UK

WOMbat ● ●
Womenswear/menswear/
 accessories
www.wombatclothing.com
Cheshire, UK

- In Britain, **1,500,000 million** tonnes of unwanted clothing and textiles end up in landfill sites per year, which amounts to **30 kilos** of waste per person

- The British clothing and textiles sector produces **20 million tonnes** of waste water per year

- The British clothing and textiles sector produces **3.1 million** tonnes of CO_2 per year

- Roughly **10%** of chemical pesticides and **22%** of insecticides are sprayed on cotton

- It is estimated that **3 million** people are poisoned by pesticides per year, which may result in numbness of limbs, anxiety, miscarriage and infertility

- Heavily subsidized cotton farming in the US allows cottong to be sold in the global market for **61%** below the cost of production, forcing cotton growers in the rest of the world to lower their own prices to compete

- An increase in daily wage for a garment factor worker from the minimum of **50 pence/ 80** US cents to **£1.50/$2.40** would increase the cost of a pair of jeans to consumers by just **80 pence/$1.30**

- Organic farming takes **1.5** tonnes of CO_2 out of the atmosphere per acre, per year

- A normal T-shirt, made from conventionally grown cotton, uses **2,000 litres** of water during production – organic and Fair Trade cotton farming may reduce this figure by up to **60%**

- Fair Trade pays cotton farmers on average **30%** more

Tom Andrews

Founder of Epona

What was the inspiration for your brand?

I was inspired to start Epona while reading *No Logo*, by Naomi Klein, which described the terrible conditions being endured by sweatshop workers. I thought: 'Why isn't there a sportswear brand that I can buy that stands for something different and treats people fairly?'

Epona started in 2002 as a sportswear brand but we now make clothing which is custom-printed with our clients' logos – for example, universities, bands, festivals, major charities. I started out with about 20k I had in redundancy money and a 10k overdraft from HSBC!

I think what has made us successful is that we make a product that our customers really want to wear. Our factories achieve very high production values; the detailing, colours and fit of our clothes have always meant that customers are prepared to pay slightly more, whether they are interested in Fair Trade or not.

How does the clothing you produce help people or the planet?

All of our clothing is made from Fair Trade cotton, so farmers get paid a fair price for their crop. They also get paid a premium, which is used on healthcare projects, improvements to the local school and water-storage projects. Some of the factories that we work with have made major improvements, both in wages and conditions, and it has been great to be a part of that.

What is the most urgent thing that needs to change in the fashion industry?

I am most shocked by the big, established factories which subcontract to sweatshops. This behaviour can easily go undetected by Western buyers because garment production has lots of different actors involved. For a simple t-shirt, there is the cotton farmer, a ginner, a spinner, a knitting factory, a dyehouse and then the final cut and sew. Most of the factories that do the final cut-and-sew part of production are used to dealing with Western visitors and most of the ones that I have seen have been relatively clean, with reasonable conditions. The worst conditions that I have seen have been in dye houses and knitting factories where Western visitors rarely go. Most fashion buyers only know about and look at the final part of production; this needs to change.

www.eponaclothing.com

PADMA KAPOOR

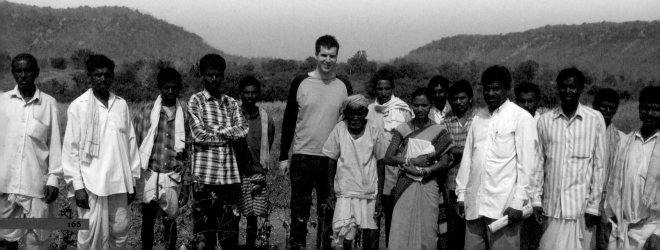

CHRIS SCOTT

What was the concept, inspiration and vision for your brand?

Junky Styling evolved from a need to wear unique, one of a kind pieces. The Wardrobe Surgery service that we offer allows the history and nostalgia of a piece of clothing to live on and increase. It encourages our customers to look at their clothes differently and perhaps purchase pieces with the intention that they can be reworked to prolong their lives from season to season.

How did you get started building your ethical brand?

We started in 1997, out of a stall in Kensington market, with funding from the Prince's Youth Business Trust match-funded by a high street bank – two or three thousand pounds initially. It was certainly our enthusiasm that got us through the early years – the term *labour of love* was certainly applicable.

Initially, the challenges were creating a marketplace and overcoming the stigma associated with using second-hand clothes. Then Liberty dressed all their windows in second-hand outfits and labelled them 'vintage' – this helped us with that challenge. We had no business training so it took a while to get to grips with that side. We know it is essential but it can really get in the way of creativity!

What is the secret of your success?

Setting up a shop in the Truman Brewery, Brick Lane [in London] was initially a bit crazy, as the area was deserted. But now, our shop is the best marketing tool. Our website now comes second. The internet didn't really exist when we started, so we got to know all our customers face to face: word of mouth and customer loyalty is how we are still here. The studio and shop in the same space has meant that we design for actual people as opposed to fictional Junky customers.

Industry recognition has been valuable. The British Fashion Council invited us to show our

Kerry Seager & Annika Sanders

Junky Styling

collections at London Fashion Week and the London Showrooms in Paris.

What most needs changing in the fashion industry?

Levels of transparency and consumption. Consume less and more wisely – we need to think about sustainability. Industry standards in the farming of cotton and production of cloth need to improve greatly.

Do you have advice for someone who wants to start their own ethical fashion brand?

Production and design are the most important elements. Being ethical isn't enough in this climate to make people want to buy a high-end item – the collection on offer has to be special through style. New designers need to perfect their signature and stick to it – through thick and thin! Also, never expand too quickly by employing too many people and taking on too many overheads.

www.junkystyling.co.uk

Galahad Clark

The creator of Vivobarefoot shoes

What was the concept, inspiration and vision for your brand?

I was already a shoemaker, running Terra Plana, when a childhood friend of mine came to me with the idea of making 'barefoot shoes'. His dad was an Alexander Technique teacher and, while doing barefoot exercises with him, he realized that his persistent sports injuries in his ankles and knees seemed to magically clear up. He created the first prototype at the RCA, where he was studying industrial design, by cutting off the soles of a pair of Nike Huaraches and stitching on a tennis racket cover as a sole material.

I instinctively loved the idea and we worked together to launch Vivobarefoot, which literally means 'live barefoot'!

How do the shoes you produce help people or the planet?

Vivobarefoot products are designed following our in-house eco-matrix principles:

Materials: Recycled, low impact, recyclability

Efficiency: Number of components, number of processes and packaging

Logistics: Easy to ship, organize, stock

End of Life: Easy to repair or dispose of – make sure minimum end up in landfill

Product lifetime: Durability and functionality.

Most importantly, we try to design and make products that:

1. Bring us closer to nature
2. Make us feel more human
3. Make us ask important ecological questions.

We work countless unpaid hours! It's hard work. We need to make sales and get people to buy ethical fashion, not just dream about running an ethical label!

What is the most urgent thing that needs to change in the fashion industry?

The consumers!

Do you have advice for someone who wants to start their own ethical fashion brand?

Have a definite reason for being and then be obsessive about it.

Who is your ethical hero?

Yvon Chouinard, founder of Patagonia, who said, 'Let my people go surfing!'

www.vivobarefoot.com/uk

Orsola de Castro

Founder of From Somewhere

What was the inspiration and vision for your brand?
In 1997 I had a collection of printed textiles and scarves. I customized and embellished an old cashmere cardigan for myself and the result was so lovely that I ended up making a few to sell as well. They sold out in a day, so I made some more and that's how it began. I can honestly say that I did not start as an eco brand; I just became one as soon as I was exposed to how much we were throwing out and consuming.

We started in 1997 with an initial investment of £500 ($800), but we've put in literally years and years of unpaid hours!

What are the biggest challenges and highlights in running your business?
They are one and the same. The biggest challenges are being so small and experimental whilst also dealing with very large companies – like Jigsaw, Robe di Kappa, Tesco and Speedo. In 2006 we also started Estethica [the Eco area at London Fashion Week] with the British Fashion Council.

On a personal level, watching Livia Firth wearing From Somewhere at the Oscars in 2010 was a big moment – the first eco brand on the red carpet at the Oscars!

Who are your customers?
Intelligent women, young and old! From Somewhere is designed to fit well around the body; we do a lot of work with our patterns and our customers respond to this. They're beautifully made clothes that will last and adapt.

As we are experimental and prone to great changes, largely due to the fact that I often don't know which materials I will find, it's difficult to market a 'signature style' – I guess we are a bit of an anti-brand.

How do your clothes help people or the planet?
Our intention is to slow down unnecessary textile production, minimizing water and energy consumption and saving beautiful fabric scraps from going into landfill and incineration.

We are a very small label and our effectiveness is dictated by the type and quantities of orders and stockists we get each season. The more we consult, the more we are able to be of impact, as with the collections we do with Tesco or Speedo. That's where the numbers and the impact are measurable.

Social issues are equally pressing: we produce all our collections in Italy in a local co-operative that helps rehabilitate disabled and disadvantaged individuals, so we are responsible through and through.

What is your favourite motto?
'Fashion is a form of ugliness so intolerable that we have to alter it every six months' – Oscar Wilde.

Orsola de Castro runs *From Somewhere* with partner Filippo Ricci.

www.fromsomewhere.co.uk

Tara Scott

Co-owner and co-director of Tara Starlet

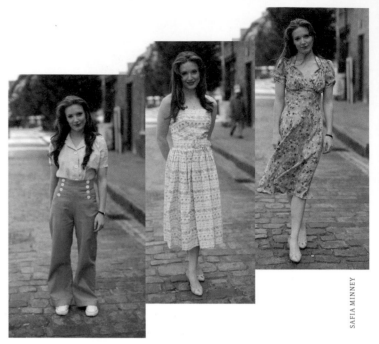

SAFIA MINNEY

Tell us a bit about how you started?

My mum has always made and sold clothes. She used to sell at markets. I've helped her since I was aged two, when she used to make cat-suits for kids and sell them at Portobello and Camden markets. I was her little model/sales assistant at age two. Our family is just me and my mum, so it's always been my responsibility to go and help her make our income. I'm 24 now; I started working full-time with Mum at 18.

How was the idea of Tara Starlet born?

Mum was making Forties dresses out of end-of-roll fabric but she was just doing one dress and making it out of loads of different scraps of fabric, and selling them at Spitalfields and Portobello market. I was helping her run the stall. Then we got approached by Topshop to be a concession there.

So did you have any formal fashion training?

No, zero – I did Art until A-level. My mother had no formal training either. She taught herself pattern cutting, her mother taught her how to sew and make clothes.

So could you explain the vision of the brand?

It's about local and family-run business. Everything is sourced and produced in London, in really small runs of just whatever bits of fabric we can get our hands on. This adds to the exclusivity, so each design will come in a variety of fabrics, but that fabric will be really limited. The aesthetic is very vintage, Forties and Fifties inspired.

Did starring on the Blood Sweat and T-shirts *TV* programme change you and those around you?

I was 21. I was passed a flyer from a friend and made it through castings and interviews. I didn't really want to do fashion, I was just helping Mum with the business – I was studying Anthropology and I wanted to go into development or even TV documentary making. I thought this would help: I was shocked by the conditions of garment factories and meeting the workers. When I went to the Fair Trade co-operative, called Creative Handicrafts in Mumbai, it was like my dream come true.

It was really frustrating that it was so short-lived. My friends were like 'oh my god that's so bad', then were buying fast fashion the next week. I got so excited as there was such a fuss about it when I got back, and we were all getting asked to go and do these photo calls and interviews. It was actually the things that came out of doing the documentary that really made me feel I wanted to get involved with my Mum's business. I wanted to use it to promote the idea that fashion can be different.

www.tarastarlet.com

Founder of Pants to Poverty, the underwear brand that wants to change the world.

What is the vision for your brand?

The idea began back in 2001 when I was working with tribal sewing groups in the jungles of Guyana. Here, I saw the power that fashion can have in empowering not only the people who make the garments but also the identity of the people that wear them. This was then followed by two years of work and travel in the Global South where I witnessed first-hand the devastation of man-made poverty and inadequacy of the proposed solutions.

At my core, I believed deeply in the power that fashion has to change the world, so in 2005 we launched Pants to Poverty to prove that what the big brands claimed was impossible was, in fact, beautiful, profitable and wholly better than the old way of fashion.

So Pants to Poverty exists to build a socially, environmentally and financially profitable model for fashion all the way from cotton to bottom, while raising the 'underwearness' of consumers and unleashing the hidden power that they have in their pants to change the world for good!

What is the business model?

We work directly with farmers and factory workers and have set up a charity to help to build structure and enable efficient distribution. Along the way, we have set up amazing social businesses which eradicate poverty and child labour and empower factory workers, establishing a real living wage and freedom of association. It has taken a huge amount of blood, sweat and tears from literally hundreds of people, many thousands of pounds of pro bono support from some of the world's leading corporations and me

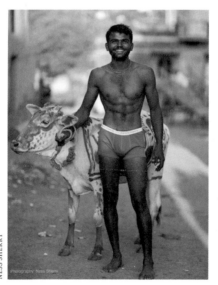

NESS SHERRY

Photography: Ness Sherry

selling my house to get it started.

Who are your customers?

Our customers are people who love fashion, hate poverty and believe that making a statement is more important than keeping schtum! They also love glorious undies!

We encourage our consumers to push even more change through – one of our biggest successes was to force Bayer Crop Sciences to pull endosulfan [a toxic pest-control chemical] off the market by mobilizing people around the world to send their worst pair of pants to them!

What is the most urgent thing that needs to change in the fashion industry?

Transparency is crucial – people need to know where their products are made and how people are treated.

Do you have a favourite motto?

I love the expression *'The people, united, will never be defeated'*, which I learned on the streets of South America. Today, with technology, globalization and the realization that resources are finite, coupled with climate change, we must not be defeated, as the consequences are not worth considering.

www.pantstopoverty.com

Carry Somers

Founder of Pachacuti

What was the inspiration and vision for Pachacuti?
Pachacuti was actually something of an accident. On a research trip to Ecuador for my MA in Native American Studies I was shocked to see the inequitable trading patterns where intermediaries made all the profits. I read Anita Roddick's autobiography and decided that if one woman could have such a positive impact on the beauty industry, there was nothing to stop me doing the same for the fashion industry.

What are the challenges you've faced?
I established Pachacuti in 1992 at the beginning of the last recession in the UK. After a successful first summer of trading, I received a £5,000 [$8,000] investment from a friend's mother, which I promptly had stolen in Ecuador, along with my business profits to date. To make Pachacuti succeed, I lived in a van, paid myself no money for years and worked 80-hour weeks. A huge amount of commitment and hard work eventually paid off and Pachacuti has grown sustainably at around 20 per cent a year, funding growth from the previous year's profits.

Only 37 per cent of women within our Panama hat association have completed primary-school education and so we are constantly searching for better ways to convey product specifications to our producers.

Who are your customers?
Our customers believe that true luxury incorporates sustainability and ethical practices. They are happy to spend money on a good-quality, rollable Panama hat. However, many of our weavers are elderly and cannot see to weave the fine-grade Panamas. Therefore, in addition to buying glasses for our weavers, we have developed a more fashion-forward range of Panama hats which are less finely woven, in order to provide continued work for our older weavers. This, in turn, has expanded our sales to a younger market.

What is the most urgent thing that needs to change in the fashion industry?
Transparency and traceability urgently need to be improved within the fashion industry to help prevent child labour and sweatshops. Pachacuti is working on an exciting pilot for the EU Geo Fair Trade project which will increase transparency throughout the supply chain. Ultimately, the consumers will be able to scan a barcode into their phone and see our entire production process, from the community-owned plantation on the coast of Ecuador where our straw grows, through to the women's weaving association in the highland region.

How does your clothing help people or the planet?
Pachacuti has been certified under the WFTO Fair Trade System since 2009. This represents important progress within the fashion industry, where supply chains are complex and added value is not determined by raw materials but by the various processes involved in the making of the finished article.

Do you have advice for someone who wants to start their own ethical fashion brand?
Ensuring Fair Trade working practices and environmental sustainability is time-consuming and challenging but essential if you are committed to monitoring your impact on producers and the environment.

www.pachacuti.co.uk www.panamas.co.uk

Founder of Gossypium

The concept of Gossypium was to showcase the lovely cotton we had discovered during our time at the Agrocel project in India. Both Thomas [Abi's husband and co-founder] and I knew how important the fibre is in making a high-quality textile.

Gossypium is the name of the cotton seed – and, having worked with farmers, we saw with our own eyes that the whole thing starts when those village farmers get themselves some gossypium seed and plant it in the soil of their small farm.

As for inspiration, the sunshine on the cotton fields, the simplicity of the lives of those farming families and their respect for and love of nature inspires me forever – buying their cotton and making a brand seemed the best way to join their meaningful work and to make sure these people were appreciated by getting a higher price for their crops.

I read that 84 per cent of people take note of 'corporate social responsibility' policies but only 5 per cent actually make ethical buying decisions. Well, we have let ourselves be guided by the people rather than by our own aspirations. We have been called a bit utilitarian at times but we sacrificed the funk for the repeat business – and it feels good to be making what people actually need.

Running a Fair Trade company is no different from running RBS or Cadbury in that you need to pay your bills and have more coming in than going out and, if you don't, someone will have to lend to your company.

Over the last 12 years, leaving the office to be at the school gate has been worth more to me than eating out in restaurants. It's the same choices you make every day in business – what's important is that you learn quickly what you do well and find people to do the jobs you are bad at. The highlights are simple – you get up every morning feeling you are doing something worth doing. Many times I've been overwhelmed by the burden of it all, feeling that I couldn't go on – and it was precisely on those days that a customer thanked me. My life and work are one and it feels good. I feel very alive and able to evolve and change as businesses have to.

We've stayed true to the early products we made that worked so well for us – yogawear, nightwear and other cotton basics. Everyone loves them.

We should buy less, better quality, longer life, higher price, more skill in production, proper returns for both producer and consumer – end of. Oh, and a bit less vanity!

Gossypium clothing helps farmers and the environment. I believe that cotton prices went down to match polyester at the golden dollar per pound [weight]. Thus the precious, small, caring farmers of this world who keep our planet green have been pushed into near starvation. Breaking cotton fibre free from the rest of 'fashion' was our first objective. It is just starting to happen.

Gandhi with his spinning wheel is my hero. I'm a big fan of manual labour – it's good for the soul, and we humans can make such beautiful things. Here's to celebrating them.

www.gossypium.co.uk

People Tree

Founder of People Tree
Safia Minney

How did People Tree start?

It started in 1991 in Japan, from a tiny seed called Global Village, a small group of people committed to change. It was possible to buy Fair Trade tea, coffee and cocoa, but not clothing – so we started to design it. People Tree grew from this and is now the highest-profile Fair Trade company in Japan. We launched in the UK in 2001. Today, we have 300 stockists in Japan and 150 in the UK and Europe and are always trying to spread our message more widely!

How does People Tree help people and planet?

As a Fair Trade company, we work closely with 50 Fair Trade groups in 12 countries and are committed to creating livelihoods for as many people as possible. We aim to benefit people at every step of the production process – growing cotton, weaving, dyeing, embroidering, tailoring – helping to empower the world's most marginalized people and strengthen communities. We create livelihoods and sustain incomes for 3,800 farmers and artisans around the world. We do pioneering work to promote ecologically sound methods of production and minimize environmental impact. We use organic and Fair Trade cotton and our clothes are made using safe dyes and steer clear of synthetic and non-biodegradable materials.

What are your greatest challenges and what are you most proud of?

Our greatest challenges are competing with fast fashion in an industry that is constantly moving. We have to order stock at least eight months before it hits the shops and make 50-percent advance payments to our producers. It's a challenge to produce beautiful, ethical clothes that are competitive in the high-street market.

The turning point was working on a designer collaboration with *Vogue Japan* and starting designer collaborations with Bora Aksu, then Jessica Ogden, Orla Kiely and Vivienne Westwood. We also worked with Emma Watson to create a Fair Trade fashion youth range – which was great fun! People Tree is now stocked in Topshop, ASOS and John Lewis. In 2010 we won the WGSN Global Style Network award for 'Most Sustainable Fashion Brand'.

Some things never change: we're still passionate about craftspeople and the planet!

www.peopletree.co.uk www.peopletree.co.jp

MIKI ALCALDE